teach
yourself

digital home movie making

W9-CUQ-795

digital home movie making
peter cope

Launched in 1938, the **teach yourself** series grew rapidly in response to the world's wartime needs. Loved and trusted by over 50 million readers, the series has continued to respond to society's changing interests and passions and now, 70 years on, includes over 500 titles, from Arabic and Beekeeping to Yoga and Zulu. What would you like to learn?

be where you want to be with **teach yourself**

For UK order enquiries: please contact Bookpoint Ltd, 130 Milton Park, Abingdon, Oxon OX14 4SB. Telephone: +44 (0) 1235 827720. Fax: +44 (0) 1235 400454. Lines are open 09.00–17.00, Monday to Saturday, with a 24-hour message answering service. Details about our titles and how to order are available at www.teachyourself.co.uk

For USA order enquiries: please contact McGraw-Hill Customer Services, PO Box 545, Blacklick, OH 43004-0545, USA. Telephone: 1-800-722-4726. Fax: 1-614-755-5645.

For Canada order enquiries: please contact McGraw-Hill Ryerson Ltd, 300 Water St, Whitby, Ontario L1N 9B6, Canada. Telephone: 905 430 5000. Fax: 905 430 5020.

Long renowned as the authoritative source for self-guided learning – with more than 50 million copies sold worldwide – the **teach yourself** series includes over 500 titles in the fields of languages, crafts, hobbies, business, computing and education.

British Library Cataloguing in Publication Data: a catalogue record for this title is available from the British Library.

Library of Congress Catalog Card Number: on file.

First published in UK 2007 by Hodder Education, part of Hachette Livre UK, 338 Euston Road, London, NW1 3BH.

First published in US 2007 by The McGraw-Hill Companies, Inc.

This edition published 2007.

The **teach yourself** name is a registered trade mark of Hodder Headline.

Typeset by Transet Limited, Coventry, England.
Printed in Great Britain for Hodder Education, an Hachette Livre UK Company, 338 Euston Road, London NW1 3BH, by Cox & Wyman Ltd, Reading, Berkshire.

The publisher has used its best endeavours to ensure that the URLs for external websites referred to in this book are correct and active at the time of going to press. However, the publisher and the author have no responsibility for the websites and can make no guarantee that a site will remain live or that the content will remain relevant, decent or appropriate.

Hachette Livre UK's policy is to use papers that are natural, renewable and recyclable products and made from wood grown in sustainable forests. The logging and manufacturing processes are expected to conform to the environmental regulations of the country of origin.

Impression number	10 9 8 7 6 5 4 3 2
Year	2012 2011 2010 2009 2008

contents

01

all about digital video and movie making

In this chapter you will learn:
- about the history of home movie making
- the evolution of movie making
- the advantages of and rationale for digital video.

We've come a long way ...

As movie makers in the digital age we have fantastic opportunities. Even the most humble of **digital** video cameras today can deliver footage of striking quality and, as we gain skills in using these cameras, those results can become even more impressive. In relative terms, digital video and movie making is a comparatively recent pursuit but as part of the history of moving images and film making it has a long and intriguing heritage – and one that has some useful lessons for us today.

A brief history of home movies

The early years

Moving images – whether at the cinema, on television or delivered to our mobile phone – are so a part of our daily lives that we rarely give them a second thought. We've also become rather blasé. A succession of Hollywood blockbusters in which anything can happen has raised – and continues to raise – our expectations and lets us regularly suspend disbelief. So when we look back on the early days of movie making we tend to risk being a little cynical about the naïvity of the business.

We need to be careful of such judgements, though. The technology may have moved on in ways the early pioneers could not have dreamt of but the basic principles remain the same, so a brief history would not go amiss.

Before the movies: zoetropes and praxinoscopes

Before moviemakers adopted film as the medium, there were other interesting but ultimately doomed devices designed to deliver moving images. Zoetropes and praxinoscopes were two common examples, popular in the late nineteenth century. Both used strips of images (that can be likened to the frames of a movie film) pasted around the inside circumference of a drum. Mirrors (in the case of the praxinoscope) or slits in the drum (zoetropes) allowed a brief glimpse of each image as the drum rotates. Seeing a succession of images gave the illusion of movement.

The drawback, of course, is that the drum is limited to a fixed number of images and so can only produces 'loops' of motion

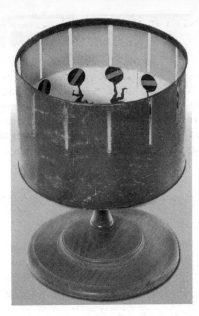

figure 1.1 give it a spin: by spinning the zoetrope and peering through the slits you get a brief moving image.

lasting a second or two. You can still come across one of these – either as an antique curio (with a price tag higher than most digital camcorders!) or as a part of a children's science kit. However, the mechanism of the zoetrope – separate still frames viewed discretely through a slit – can be traced to cameras of today.

What the Butler Saw

Rather salacious in their day, these fairground and end of the pier amusements achieved their notoriety not only on account of their subject matter but because they were the first introduction to movies to many people. They overcame the modest number of frames possible when using a zoetrope by adopting a flick-book approach where hundreds of still images were 'flicked' in front of a viewfinder momentarily to give the illusion of movement, movement that could continue for several minutes as the viewer rotated the handle.

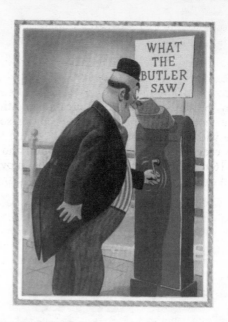

figure 1.2 What the Butler Saw: an early attempt at delivering moving images.

Dawn of the movies

In a world where moving images were a novelty, What the Butler Saw machines (and their equivalents that offered shows of a less salubrious nature) had tremendous impact. Such was this impact that the race was on to produce a method of showing movies (a term coined to describe all collections of moving images) that was not limited in length by the reels of still images and could be presented to large groups of people at one time. The solution was movie film. The invention is generally accredited to the French Lumiere brothers who did so much to pioneer early movie making but others, too, claimed the prize. For our purposes here we should skirt around this potentially contentious issue!

In the early days there was little to distinguish the amateur filmmaker from the professional. This was definitely a rich man's activity (albeit with the occasional woman), for only the wealthy could afford both the necessary hardware and the time. Indeed, some of the inspired amateurs crossed the divide and became professionals themselves as they realized that there was an eager market for the films that were the result of their

pastime. However, there was a definite majority for whom the pursuit of movie making would always remain a hobby.

As time moved on a clear differentiation appeared in the marketplace as movie making kit designed for a growing amateur band of enthusiasts developed. Scaling down the large formats of film used by the studios allowed the creation of affordable – in comparative terms – cameras, projectors and associated gear. Halving the width of film from 35 mm to 16 mm was the first step, but as even smaller gauges – first 9.5 mm and then 8 mm (ostensibly 16 mm film, split down the middle) movie making – then dubbed cine photography – entered the mainstream.

Compared with those of their forebears, cine cameras were compact and portable. Compact enough for the new generation of devotees to take with them everywhere. From the 1960s onwards every aspect of family life was captured, from the casual day out through weddings and christenings to holidays taken in increasingly exotic locations. Viewed in retrospect, these casual recordings provide intriguing social commentary and have successfully captured ways of life that could all too easily – like those of previous generations – have gone unrecorded and been lost for good. However, there are still many people who can remember the trepidation with which they approached the invitation to spend an evening viewing a friend or relative's movies. Time, here is most definitely a great healer!

The rise of video

As cine photography and home movie making continued to gather converts through the 1970s, change was afoot, change that would decimate the marketplace for cine photography. Ironically, this was change that would stimulate the market for movie making like never before. We are talking, of course, about the dawn of the video age. Curiously, the first steps in video photography were seen by almost all observers – and certainly by most cine enthusiasts – as something of backward ones. These first cameras were based on the contemporary home video formats and these formats – Betamax and VHS could never be described as 'compact'. The first cameras to exploit these formats were bulky and, in use, unwieldy, aping the movie cameras of half a century before. Cine photographers, proud of their compact and capable cameras could afford a wry smile at these initial efforts.

Promotional media tried – in a very literal sense – to make light of any concerns about weight or size. Catalogues showed women (presumably in a now-questionable marketing sense, to convey how convenient the cameras were) filming childrens' parties, holidays and all the other staples of the cine photographer. There was no mention of what a burden this hardware could be when carried around all day!

Using these cameras was certainly a labour of love as you battled with both the weight and the limited specification. The payoff was movie footage that was of better quality than most cine movies and the convenience of being able to replay those results on a television. No longer was there a need to unpack and deploy a movie projector and screen every time you wanted to enjoy your movie collection. There was no doubt that the future of cine had suddenly become very much more uncertain.

These video pioneers were setting the pace for early video photography even though their recording equipment comprised cumbersome two-piece units (many early models had separate cameras and recording decks). They would have known that it was only a matter of time before their prize cameras would be superseded by increasingly more compact models. And so it was. The original size restriction – determined by the size of the videotape cassette – was overcome when **Video 8** and VHS-C replaced the large Betamax and VHS cassettes respectively. These were formats designed specifically for the video camera (now christened camcorder) market and both enabled an order of magnitude shift in camera size, raising portability to the fore in camera specifications. Video technology had caught up with, and passed, cine. Quietly, and mourned by the few, cine passed into history. And that's where it now languishes, supported only by a few stalwarts.

Video in the mainstream

Although overtaking cine was a milestone for video technology it was by no means the end of the story. Video had brought the hobby once enjoyed by a select few to us all. A huge market was opening which, by the nature of these things, meant the prospective video photographer (and migrating cine enthusiast) had an unrivalled range of camera models from which to choose. From basic point-and-shoot models through to those capable of results close to that of a pro, there was a model for every ambition and almost every pocket.

If the change from cine to video could be described as evolution, then the next change – to digital video – was revolution. To most of us the introduction of digital video formats appeared merely as the introduction of a new tape format – a format substantially smaller than even Video 8 and one that would allow even more compact camcorder design. In fact, as we now appreciate, digital video brought benefits that outweighed that of merely a smaller tape size.

First, quality. Let's face it, in a world increasingly dominated by **high definition** television broadcasts and where even **standard definition** broadcasts offer remarkable clarity and definition, the pre-digital **analogue** formats offered quality that could never be described as more than so-so. Even the so-called hi-band versions of VHS and Video 8, SuperVHS and **Hi8** could only offer a modest improvement, insufficient to satisfy an increasingly demanding circle of consumers. Early proponents of digital video described the format as offering broadcast quality pictures. That was, in a technical sense, true, in that the **resolution** of digital video matched that of standard definition television (and was streets ahead of analogue), though broadcasters were quick to point out that a simple **DV** camcorder could not replace their broadcast-standard cameras!

Second, and ultimately more significant, digital video allowed computer-based editing without loss of quality. It had always been possible to edit cine film of any format, in exactly the same manner as full-sized movie footage. There was something of an art about it and practically, it was an activity generally reserved for the true enthusiast. Now it's possible to edit and embellish your movies, adding professional titles, transitions and special effects with the minimum of effort. Best of all, there is no measurable loss of quality between the original footage (a term that persists from the days of real film!) and the edited. Try editing analogue footage (by copying from one VCR to another) and quality falls off rapidly.

Now, digital video is de rigueur. Camcorders continue to evolve, with some models offering solid-state storage (as in a digital stills camera, via a memory card) or **DVD** recording. The quality range, too, has been enhanced in both directions. At one end – which we might call the top – digital video recording has been enhanced to deliver high definition quality recordings, essential for a marketplace increasingly aware of, and used to, this format. At the other, scaleable video recording technology makes it possible to offer video recording on mobile devices

such as phones and the increasingly common hand-held PDAs – personal digital assistants.

As for movie making, whether you go for standard digital video, high definition, or even a mini masterpiece from your phone, creating a movie has never been simpler. And whether you want to enjoy the results yourself on a TV or share with friends via the internet or by disc, professional results are only a few clicks away.

figure 1.3 movies in your pocket: some video cameras today vie for size with MP3 music players. Along with video cameras built into mobile phones they mean you never have an excuse for not having a camera with you.

The digital video advantage

'Digital' is a term that is bandied around in all walks of life often by marketeers who see it as a synonym for 'cutting edge' and it now appears in almost every walk of life: digital radio, digital phones, digital cameras. What does it really mean, especially in the context of digital video? And what, specifically, is it that makes digital video so superior to earlier, analogue formats?

Digital, in its most common, if clinical, meaning describes the way in which real world information – such as sound, colour and light – are converted into numeric form. This means that we can represent a piece of music, for example, by a string of numbers. When we want to copy the piece of music, we copy the

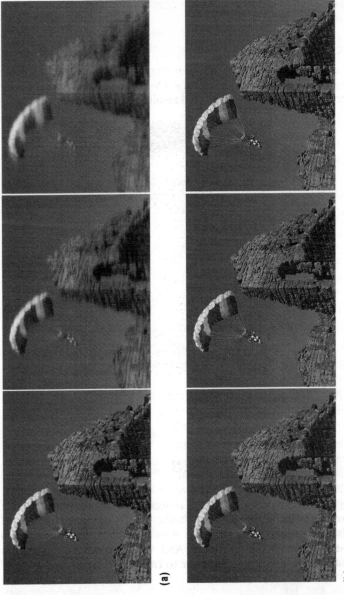

figure 1.4 analogue video: copy an analogue video tape and the resulting image loses definition. Copy that to another tape and the picture becomes very poor **(a)**. Compare this to a digital original that remains consistent from copy to copy **(b)**.

numbers. This process, unlike copying analogue sound, is less likely to suffer loss or distortion: the copy will be as good as the original. So it can be, too, with video. Rather than an analogue signal, a digital, numeric signal represents our scenes.

When we talk about digital video the key distinguishing feature is its quality. A digital video signal – such as that produced by a sensor in a digital camera – doesn't suffer degradation in the same way as an analogue signal. A single frame of video will be more sharply defined than that from an equivalent analogue camera. Digital video really comes into its own when we start thinking about editing.

If you've ever copied a conventional video tape to another – perhaps making a copy of that treasured wedding video – you'll know that the copy isn't a patch on the original. Copy the copy to another tape and the picture will be badly degraded.

In the digital domain you can make copies (and copies of copies) with virtually no degradation. That's why editing digital video is viable. Better still, you can edit with the most modest of equipment.

Quality and compatibility: pushing the limits

The quest for quality was a major driving factor on the road to digital video. Digital video now offers every one of us with comparatively humble cameras and editing equipment the opportunity to record video at virtually the same quality as that offered by television studios.

Interestingly the process of offering improved quality did not stop when digital video became popular and widespread. Television companies wanted to offer even better quality television pictures and, alongside, better quality sound. Along with the electronics companies the result was High Definition television – or **HDTV**. Rather than the 625 or 525 lines that go to make up a standard television picture, HDTV pictures comprise either 720 or 1080 lines. That means a far more detailed television picture and one ideally suited to display on televisions that were of ever-increasing screen size. It should come as little surprise that the consumer electronics business was not far behind and soon HDTV camcorders appeared,

letting you or me – at a price – take advantage of this superior resolution. Now that more and more manufacturers are offering this format it's possible to produce high quality movies, at home, that you can project to cinema proportions!

However, digital video is not just about the biggest and best – it's about flexibility and compatibility. For every person that would like to make a big-screen HDTV blockbuster there are many more that want to share memories of important events via the web, CD, or even by mobile phone. The great thing about digital video is that it caters for all these new marketplaces. Your next movie could hit the big screen ... or your friends' video iPods!

Through this book we'll explore all these opportunities and see how many of them fit together.

Where film is still king

It's easy to dismiss conventional film and movies in the light of the inroads due to digital technology, especially when we consider that movie cinemas are progressively adopting digital media for the delivery. This migration to digital hasn't yet hit one type of movie theatre, the IMAX. IMAX movies are popular because they offer massive, high quality images and the option for three-dimensional presentations.

The ability to fill a screen that can be 20 metres or more high and still offer fantastic image quality is down to the original film and the projection method. Rather than the already-large 70 mm film (twice the width of 35 mm) used for the highest quality for conventional movies, IMAX uses an even larger format based on running 70 mm film sideways through cameras and projectors. Add to this a projector that uses vacuum technology to ensure that the film is held firmly at best focus for every frame and the result is astonishing sharpness.

Though three-dimensional video photography is possible, using specialist cameras, digital technology doesn't offer the option of image qualities on a par with IMAX. So, for the moment, here's one group of movie theatres that can boast that film is still king!

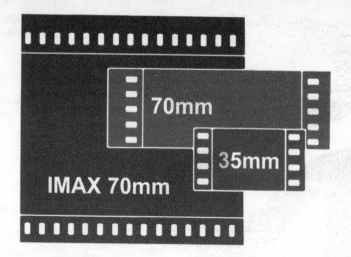

figure 1.5 film comparision: IMAX movies are shot on 70 mm film but, running sideways, it offers frame sizes much larger than normally possible on this film format.

figure 1.6 IMAX theatre: as befits their unique status, IMAX theatres tend to be iconic buildings, such as this, at Futuroscope in France.

02

choosing a digital video camera

In this chapter you will learn:
- the best ways to find your perfect video camera
- about different video recording formats
- to understand the key components of a digital video camera.

If you are new to digital video – whether that's as a complete novice or as a graduate from conventional video (or even cine photography) – shopping around for a new digital video camera can be a little bewildering. There's no doubt that there is plenty of choice out there, both in terms of models and complexity. Through this section we'll take a look at the key elements you need to take into account when looking for new kit. We'll help you draw up an essential shopping list, ensuring your purchases will be capable of delivering the results you need.

Cameras should come top of the list of equipment, although this is not such a no-brainer as it might at first seem. You don't need a video camera to get into digital video. How come? Thanks to resources such as Google Video and BBC Motion Gallery you can get into the editing aspects without shooting a single scene yourself!

But, to be honest, the reason most of us get into digital video – or want to get into digital video – is because we want to record events that are important to us. The fact that we can then edit our movies and make them into something extra special comes as a bonus.

If you have a video camera already you may be set to go straight away – and you will no doubt have a substantial tranch of video recordings awaiting editing. Should that camera not be a digital model that does not preclude you from editing digitally. We'll see later (page 188) that it's perfectly feasible to edit your old and cherished recordings.

In the next chapter we'll take a look at the equally bewildering world of accessories. There are thousands – perhaps tens of thousands – all claiming to be essential and all competing for your hard-earned cash. Let's sort the proverbial wheat from the chaff and establish which accessories are essential and which are better left on the photo stores' shelves.

Shopping for your digital video camera

The problem we face when we set out to acquire a digital video camera is that whatever our budget and whatever our aspirations there is a huge amount of choice. We need to turn the diverse marketplace to our advantage; by doing our homework we can ensure we make the best choice.

It's useful and practical to divide the whole digital video camera world into the three categories that we can describe as beginner, enthusiast and prosumer. Beginner models are those that offer simple controls and, in particular, allow us to record good movie footage without needing to know too much about the technicalities. They are not necessarily just for beginners – they appeal too to those of us who don't want to get too involved in the technicalities of digital video cameras.

Enthusiast models offer the same simplicity – if required – but will also allow the user to control their movie making by, for example, controlling focus or the exposure. These cameras tend to be more expensive, reflecting the added control incorporated.

Prosumer models are for the very serious enthusiast – ones that may be, for all intents and purposes, verging on the professional. These cameras will offer ultimate control but, by this nature, will be less friendly towards the newcomer or the less skilled.

To be honest these categories are not precisely defined but you'll probably have an inkling on what group you belong to. Over the next few pages take a closer look at the features and how they deliver the quality we need for our videos.

Doing the homework

Fortunately, we don't need to travel the high street and shopping malls to start on a quest for a new video camera. We can do the groundwork at home via the internet and video magazines.

You'll find yourself spoilt for choice in the websites available. Some sites concentrate on reviewing cameras. They are impartial and provide a service principally to the buyer. Then we have sales and shopping sites that are packed with reviews. Amazon, for example, features many of the latest video cameras on its pages and also solicits views from existing purchasers (whether they purchased from Amazon or not) to help rate each model for intending purchasers.

It's easy to be cynical about these sites – you would not expect the site to host bad reviews of models they were actively trying to sell – but in fact, you'll find warts-and-all reviews of many models. Only the reviews with malicious intent (or, conversely, those that are too positive to be independent) get filtered out before use.

Scan these sites – and never confine yourself to a single one – and you should be able to draw up a shortlist of models that meet your criteria. Here are just a few questions that you should be asking yourself when shortlisting. Use this as the basis for your own checklist but don't limit yourself to just these!

- How much can I afford to spend?
- Do I need a model I can point and shoot, or something offering more control?
- Is camera size important, and if so, do I need a pocketable model?
- Do I need a large **optical zoom** ratio?
- What recording format is required? **MiniDV**, DVD, flash memory? And what is a recording format?
- Which format is best for my needs?
- What video quality do I need and will I need to produce high definition video?
- Does the camera have special modes that help in the type of video photography I enjoy (or plan to do), such as low light level or action sports?
- Do I need to be able to take good quality still images?
- What sensors do the cameras have?
- What extras do I need?

If you are new to digital video, some of those questions may sound baffling! So that we go into battle properly forearmed, let's look at these questions again and add in some background notes.

How much can I afford to spend?

Normally, the more you spend, the better specified the model that you can obtain. You do need to be mindful, though, of whether a better specification is actually what you need. A good solid point-and-shoot model may better suit your needs if you want a camera that can be taken anywhere. And also new technologies command a premium price: moderately spec'ed hard disc cameras and high definition machines will cost the same as a top spec conventional tape-based camera. Costs are not limited to just the camera. You'll need to budget for some essential accessories (if that is not something of a contradiction in terms) such as spare batteries and, depending on camera type, media such as tape, DVD or memory cards (see 'What extras do I need?' page 23).

Do I need a point-and-shoot model or something offering more control?

This is down to your needs and aspirations. Most of us will get more benefit from a simple (and cheaper) point-and-shoot model. These are ready for action at all times and take great footage under most conditions. If your needs are specialized, though (for example, you plan to shoot a lot at night or under adverse conditions) a model offering more control will be a safer bet. You can point and shoot with these too, but the cameras with more controls tend to be a little bulkier.

Is the size important, and if so, do I need a pocketable model?

For some of us, digital video becomes an all-consuming passion and we're happy to transport our video camera – no matter what the size – with us everywhere. But for the rest of us the camera is there to be on the sidelines, metaphorically, and record events. In these cases you may want a model that can easily be slipped into a pocket or small bag so that it's always ready for action.

Do I need a large optical zoom ratio?

A large optical zoom lets you film small distant objects from a distance or get in close to details in a scene. To make best use of a powerful zoom you'll also need a tripod to prevent shake. For general photography a big zoom is useful but not essential. A smaller zoom will be fine for filling your frame with your family at play! Be mindful that a **digital zoom** – something that appears prominently in camera specifications – is not the same and should given a wide berth. Digital zooms don't give sufficient performance.

What recording format is required? MiniDV, DVD, flash memory?

All cameras work in the same way, right? Well, that's broadly true. In terms of the way that the lens produces an image, that image is converted to an electronic signal and processed, the fundamental method doesn't differ – except in the detail – from one camera to another. However, the way that the processed

electronic signal – which represents our movie footage – can be stored does differ. We refer to these ways of recording the signal as recording formats.

So why are there more than one format? Various reasons: some commercial, some technical and some practical. It's useful to think of this as akin to recording live television. To record our favourite TV programme we could use videotape. Nowadays we tend to use the VHS format but a few years ago we might have used Betamax or even Video 2000, or we could use recordable DVDs. Each of these recording formats is equally valid; some are more convenient, some offer better quality.

So it is with digital video cameras. They offer several different formats and recording methods including MiniDV (a small, digital video tape cassette like a very small VHS tape cassette), DVD (similar to the format used at home for recording 'live' television) and flash memory. This latter format will be familiar to those who use still digital camera. Flash memory comprises memory cards that can be slotted into the camera to record. Here are the details of the formats you are likely to encounter during your shopping expeditions.

- *MiniDV* We might describe this as 'the VHS of digital video' in that it's by far the most popular format and the one found in most digital video cameras. First seen in 1996, it has become widely used in both the consumer and semi-professional arenas on account of its high quality. It is also a cheap format – tapes are widely available at low cost and, because the tape size is small, results in compact camera designs. To get technical for a moment, the format is especially easy to download to a computer for editing. Virtually every MiniDV camera can be connected using a **'FireWire'** cable (a special fast communications cable supplied with the camera). MiniDV is especially popular with home movie makers. You'll find MiniDV cameras available in beginner, enthusiast and prosumer cameras.

- *HDV* In the last chapter we mentioned high definition television – television offering much higher picture quality, up to four times better than 'standard' television. Digital video cameras using the HDV format can record video at this much higher quality. Is this for you? If quality is paramount, yes. If you are happy with conventional video recordings or plan to produce videos designed to be shared

over the internet, then no. As you might expect, **HDV** cameras command a premium price.

- *DVD* Recordable DVD offers convenience – you can remove the DVD from the camera and play it directly on your home DVD player. No need to connect the camera directly to the TV or to transfer footage from tape via your computer. Quality is broadly on a par with standard MiniDV video recordings but DVD camcorders tend to be favoured more by those who prefer the convenience over the ultimate ability to edit the footage on a computer.

- *Digital 8* Now fading into obscurity. Nothing wrong with the format (which was essentially a digital version of the once-popular non-digital formats, Video 8 and Hi8). It conveniently allowed these tapes to be replayed and, in most cases, digitized for editing on a computer. This proved an ideal solution for those with large collections of older videotapes.

- *Microdrive/HDD* Essentially removable mini computer hard drives, microdrives and hard disc drives (HDD) were first seen in digital stills cameras where they overcame the problem (at the time) of the limited capacity of the memory cards – conventionally used to store images. Original microdrive cameras could store 60 minutes of MiniDV equivalent footage on a 4GB drive (that's the same size of drive that you'll find in some older iPods, sufficient for a couple of thousand music tracks) but later models exchanged the removable drives for fixed ones of an even greater capacity of 30GB or more. This allows commensurately longer recording times at high quality and proportionately more if a lower quality setting is selected. Footage can be downloaded periodically to regain free space on the hard disc.

- *Flash memory* Better known as memory cards, flash memory tends to be used where very small cameras are required. In this market where size is crucial video quality comes second and so most flash memory-based camcorders tend to offer lesser quality recording modes than alternate formats. As such they may not be sufficient for discerning video photographers but for web video and non-demanding applications they provide a convenient and compact solution. Another plus is that, with no moving parts (as in a disc drive, tape or DVD camera) these cameras – and the cards themselves – tend to be more robust: great if you expect to treat your camera with less than perfect respect!

- *Analogue formats* Preceding digital formats, analogue formats were once commonplace. The advent of digital formats relegated them somewhat as their quality is lower than the principal digital formats (sometimes substantially so) and they need to be 'digitized' before they can be uploaded to a computer for editing.

As a quick rule of thumb for your shopping list you need to be aware that:

- MiniDV is the most widely used and most compatible with video editing software.
- DVD is convenient in that it allows quick replay using home DVD players or computer DVD drives.
- Flash memory, with no moving parts, is more robust, but high quality cameras that use the memory cards tend to be more expensive.
- Hard disc drive cameras offer the potential of high quality but are limited in recording times. If you are a prolific filmmaker you'll need something that offers greater recording times.

Which format is best for my needs?

For general purpose, good quality video, look for digital video cameras that use the MiniDV format. You'll find MiniDV cameras ranging from cheap, simple to use models through to professional grade. If you expect to edit a lot of your video recordings, MiniDV makes this simple. Some may consider this contentious but our advice would be to audition MiniDV based models first.

If you are in the market for a high quality enthusiast or prosumer camera, shortlist HDV models. Because these cameras use MiniDV tapes they can also be used to record in the standard MiniDV format as well as the higher quality HDV so, in a sense, you can then choose between the two qualities at will. You can select either recording mode prior to shooting a scene.

DVD cameras are great if you want to shoot video and watch it straight away. It's ideal therefore, if you don't plan to edit all your movies. In general DVD camera are aimed at the beginner and the casual video photographer – those that want good video

recordings but don't necessarily want to get embroiled in the technicalities of editing and copying.

Much the same can be said of the HDD and flash memory cameras. These cameras are mainly designed with convenience in mind. That's not to say that they can't offer good results and good video quality but it's in simplicity of use that these models really score. These are general-purpose cameras ideal for beginners and the more compact flash memory models are especially useful if you need (or want) to carry a video camera with you everywhere.

It's best to give analogue and Digital 8 formats a wide berth now. Analogue formats just don't offer sufficient quality and are problematic to edit on a computer. Unless you have a large collection of Video 8 and Hi8 videotapes that you would like to transfer to a computer for editing there isn't a sufficient case for Digital 8. There are no new cameras produced in this format so support for it is definitely on the wane.

What video quality do I need and will I need to produce high definition video?

In photography generally we say that you can never have too much quality. But, if your aim is to produce video that will be posted to websites, shared over mobile phone networks or distributed on conventional CD, the highest qualities will be superfluous. You can set some flash memory cameras and hard disc drive models to record at a lower quality than standard, which is often still sufficient for web use. A benefit of this is that the recording time is often increased proportionately for each flash memory card or hard disc drive.

Make no bones about it, MiniDV offers very good quality. Your movies will be sharp and colours well defined but high definition HDV offers even greater quality, quality that can help you deliver great movies that can be enjoyed on the largest television screen.

figure 2.1 quality: look closely – or not so closely – at some video and you'll see how the quality differs. The first of these shots was recorded with a small, cheap video – perfectly satisfactory for web use, but no more. The next is standard DV – what most of us will use. The final is high definition – much higher quality but needing a high definition television to enjoy.

Does the camera have special modes that help in the type of video photography I enjoy (or plan to do), such as low light level or action sports?

Some cameras have special modes that configure the controls to best shoot specific types of action – rather like the specialized modes on some stills cameras. These can be really useful if, for example, you plan to shoot a lot of fast moving sports, landscapes or night scenes.

Do I need to be able to take good quality still images?

Just as stills cameras can shoot movie footage, movie cameras are increasingly adept at shooting stills. Our advice, though, would be to select a movie camera on the basis of its movie performance. You'll always get better still photos using a stills camera.

What sensor do the cameras have?

A sensor? Think of this as – in very loose terms – equivalent to film in a film camera. This is where the image formed by the lens is focused. Unlike film, of course, the sensor is fixed and does not move through the camera. Instead the electronic circuits connected to the sensor record the signals produced when an image is formed on it. Lest we get needlessly technical at this point, it's probably best to think about sensors in this way: larger sensors generally give the best results and more detailed images. Cameras which offer three sensors give even better quality, but at a cost. You'll find that when shopping for your camera the manufacturers boast about the quality and, where relevant, the number of sensors provided.

What extras do I need?

In the next chapter we'll look at the countless accessories on offer for digital video cameras but some items should be considered more of an 'essential' rather than an 'accessory'.

Batteries

They are the bane of the video photographer's life because, like tape, you can never budget for how much power you will need. It is probable that your camera came with a battery of modest proportions that isn't really up to the job of extended recording sessions. Buy a higher-powered one, and keep the original – fully charged before every assignment – as a spare. Better still, get a second high-power one to ensure that you've enough power to last all day.

Recording media

You'll also need to equip yourself with sufficient recording media – that is, the tapes, DVDs or memory cards that your camera needs. Though you'll be able to reuse most media (except for record-once DVDs) after transferring your video footage to a computer, you'll need sufficient tape to cover your recording needs. Also, you may want to keep 'original' tapes just in case you want to review the recordings later.

figure 2.2 consumables: you can never have enough; strip these DVDs from their boxes and they'll take up little space in your kitbag or holiday suitcase.

Whatever media and consumables your camera uses it's important to be aware that if you are travelling or you are a long way from the usual outlets getting hold of spares could be problematic. If miniDV tapes are difficult to find, DVD-R discs may well be impossible!

Hands on!

So we've a long list of criteria already. Hopefully we've now explained a little of the confusing terminology but here are a few more pointers to help you home in on that perfect model, especially as we now head for some hands-on experience!

First impressions

No matter how good the camera it has got to feel good to you. There's no real alternative to getting the feel – in your hands – of your short-listed models. Ask yourself: does the camera feel comfortable in my hand, and do the important controls fall naturally under my fingers? This may be the first time that you've held a camcorder or you may be experienced but, either way, are you able to hold it and operate the controls easily? If you are left-handed, or prefer to use the camera in your left hand pay particular attention to this stage.

figure 2.3 spoilt for choice: there is such a wide variety in both the size and the complexity of digital video cameras that it's important to do your homework before taking the plunge.

figure 2.4 small cameras: yes, it will fit a pocket or a purse, but are the buttons sufficiently large to operate without difficulty? Trading off size for ease of use will be something of a personal decision and based on your intended uses for the camera.

figure 2.5 camera controls: good ergonomics are essential if you are going to feel comfortable using your camera. Check that all the buttons you use most frequently (including the on/off/shoot and zoom controls) fall easily under your fingers.

Camera manufacturers spend a lot of time on the design of their cameras. It's also true to say that often some sacrifice usability for size (which is okay – you may be happy to compromise for compactness) or for the sake of 'showroom appeal'.

How easy is it to set controls?

Cameras have no standardization for setting secondary controls. On some models it's via some obvious buttons, on others you need to navigate sometimes-tortuous menus. Some even use touch sensitive liquid crystal display (LCD) panels – the foldout screens also used to display the view through the lens – in place of physical buttons. No type is 'best' but some are more user friendly. Personal preference is important to take into consideration here, but if you know you are likely to want to manually focus a lot, it makes sense to check that the manual focus selector and the controls are easily found and applied.

Lens

How well does the lens focus? Using the camera in the camera store is a good test because store lighting is often on a par with typical domestic interiors, of the type in which we might use our cameras. Does the lens focus quickly on a subject? Or does it tend to hunt backwards and forwards before finally settling down? And what about the zoom? Easy to use and precise? Or less distinct?

Shine the camera at some bright lights. Does the image lose contrast and show flare (bright lines and stars around the light), even when the camera's not pointing directly at the lights?

Viewing

Expect the LCD viewing screen panel to present you with a good representation of what is being recorded, but how easy is it to see the screen? It should be okay under normal lighting conditions but what about in bright sunlight? Does the screen 'grey out' or is it still viable to view and compose? Does the camera have an alternative such as an optical viewfinder? If so, does it present all the information you need, such as time and date, recording time available and so on?

What is the picture quality like? And the sound?

Obviously the last two questions can't easily be answered in the store. This is where we need to take our testing one stage further. You'll need to equip yourself with some blank media (discs, tape or memory cards) and shoot some real footage with your chosen cameras. You shouldn't get any objections from the staff at the store – after all, this is part of the process to select the best of the bunch and once you've sussed the best, you'll be purchasing.

As you take your recordings try the following:

- Shoot some continuous footage moving from the store interior to the outside. This tests the camera's **white balance** control and establishes how well (and how quickly) the camera can adjust its recording profile for different lighting types.

- Shoot some fine text, or some foliage. We can examine these recordings later and see how sharp the recordings are. Some cameras can overprocess images to increase the perceived sharpness. This can give grainy results for fine, contrasty detail as we might see with black on white text or in the fine detail of foliage.

- Shoot some blue sky. Or, failing that, some overcast sky. Operate the zoom control from widest setting to longest. This will show you how close you can get to distant subjects (when set to the longest setting) and how much of a scene (interiors for example) that can be included at the widest. At the same time check whether the lens suffers from 'vignetting' – a darkening in the corners – at some zoom ratios. Most wide range zoom lenses will suffer a little from this but check for any strong dimming in the corners of your shots that could spoil your video.

- Check the camera's sound. Record people talking and (when you come to replay the tape) assess how clear that conversation is and how much ambient **noise** and camera noise intrudes.

You'll need to take the recordings home and compare them qualitatively. Of course, if this is your first purchase and you need to replay a MiniDV tape, you may have to impose yourself on friends or family with a camera of the appropriate format.

figure 2.6 oversharpening: some cameras produce sharp-looking results by applying digital sharpening techniques. This works well most of the time but on some subjects you can get very artificial effects such as shown here in the lower image.

figure 2.7 vignetting: dark corners are symptomatic of vignetting. Most lenses show this problem to some degree (especially at the wide zoom ratios) and it is more prominent against backgrounds of constant colour or tone such as a clear blue sky.

Buying a pre-loved camera

Or, a second-hand model as we'd call it. Is it safe or sensible to buy a second-hand video camera? That's something of a contentious question. Video cameras are notoriously expensive to repair, should a repair be necessary. Older cameras, statistically at least, tend to break down more often and are less likely to be covered by any form of warranty. Even a reputable camera store will shy away from providing a guarantee for anything more than a few months.

On the other hand, cameras are pretty reliable so a well-priced second-hand camera could be a good investment. Check the quality of the recordings from any camera – sound and vision. The nature of digital video is such that recordings can look very good even when some components – especially tape heads (the majority of second-hand recorders feature one of the main tape formats) – are close to failure.

Buying from a reputable store should give you some reassurance or factor in the cost of a third party extended warranty.

What to avoid

Anything you should leave off your shopping list? A couple. Digital zooms head any list. A digital zoom doesn't use lenses to zoom in close on distant objects. Instead the camera records a smaller and smaller part of the image on the sensor and enlarges it to fill the full screen. The more you zoom with a digital zoom the poorer the picture resolution becomes.

Second, in-camera special effects. Even the most elementary of movie editing software applications can provide a whole range of special effects that you can control with a surprising degree of precision. The trouble is that, if you apply special effects to your original footage (and here we are talking about special effects such as black and white, sepia tones, mosaic **pixellation** and more) there's nothing you can do to remove these effects if they don't work as part of your movie.

In practice you'll find that most cameras will feature wide ratio digital zooms and special effects as a matter of course. Neither contributes much to the cost base of the camera so you'll need to regard them as features that are there when you need them – but that you'll probably never have cause to use them.

Summary

As you head off to equip yourself with a new or updated video camera, keep these points firmly in mind:

- *Try before you buy* Specs and looks on paper – or on a web page – don't necessarily convey how the camera will behave in your hand. Cameras can be larger in the metal whilst other, smaller designs can prove too fiddly to use for extended periods.
- *Understand the formats* Each format has strengths and weaknesses. Check that the profile for your chosen format closely matches your shooting ambitions.
- *Check the view* Some LCD screens can become useless in bright sunlight, so check this on your chosen model. Look for a viewfinder if this is the case – and remember that viewfinders can save precious battery power.

- *Focus on the optical zoom ratio, ignore the digital zoom* Remember that the digital zoom is only magnifying the central part of the sensor's image and not magnifying the subject to deliver a closer view. Don't be seduced by the huge digital ratio if zooming is important – pay more attention to getting a camera with a good optical zoom ratio.

- *Get a bigger, better battery – or two* Don't expect exceptional performance from the battery supplied with your camera. Invest in a higher-power, longer-lasting model. Better still, get two to cover you for those long shoots.

- *Take a look at the sound* A *look* at the sound? Front mounted microphones are best, top mounted ones **capture** the sound all around – not just in the direction of shooting. For the best sound, count on adding an external microphone. You can attach it when great sound is essential.

- *Buy your camera!* You'll find that websites and online stores tend to advertise the best prices but that many high street stores will offer similar (if not identical) prices when pressed. Or you may find that the high street stores will throw in some useful accessories that make their initial higher prices more attractive – particularly if they include accessories you intended purchasing anyway. Make sure too that you get the best warranty included (though extended warranties from stores can be more expensive than equivalent policies offered by third parties) and that the batteries (and memory cards, if appropriate) offer the best life and shooting durations.

03

accessories

In this chapter you will learn:
- which accessories should be considered 'essentials'
- how certain accessories can enhance our movie productions
- about using photographic accessories for helping shoot better video.

If you're moving to digital video from conventional stills photography no doubt you've a gadget bag packed with all those 'essentials' you need for your photography. Dig a little deeper and, be honest, you'll find lots of accessories that haven't seen the light of day – or the light from your camera – for a long time. That's the trouble – and the fun – of photography. There are plenty of things to tempt you to part with your paycheque of which very few actually earn their keep or become a solid ally in your quest to better photography.

Digital video is no different, except that those accessories are, if anything, even more pricey and can be even more esoteric – and so tempting. Let's look at the equipment you need to get going in digital video. We'll also explore which accessories are useful, those that might be desirable and those that are a definite no-no!

Camera cases

Your video camera is a precious investment and it pays to keep it as safe as possible, especially when not in use. Cameras today are surprisingly robust but that shouldn't be an excuse for unnecessarily rough handling. It's unfortunate that the most protective of cases are also the heaviest and most cumbersome.

Rigid ABS plastic (that allegedly can survive a run-in with a rhino) and aluminium are favoured by professionals the world over. Put your kit in one of these and it'll be safer than you in

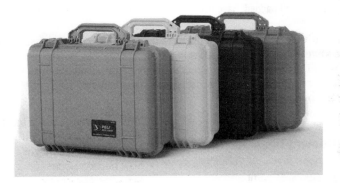

figure 3.1 rigid cases: ideal for air transportation, these rigid cases from Peli claim to withstand almost any impact. Ideal for professionals, they are too heavy-duty for the rest of us!

most circumstances. Of course, though we may be aiming to be professional in our approach to movie making we're not able or willing to live the professional's lifestyle. We need to look for the best bag that fits in with our lifestyle even if that means a modest compromise in ultimate protection.

The market is awash with suitable bags but many of these overtly shout 'expensive photo equipment inside'. If you plan to travel a lot it makes sense to go for a bag that – to anyone with designs on your equipment – is more likely to shout 'paperwork inside' or even 'lunchbox'. Safety and security should be paramount.

figure 3.2 gadget bags: bags such as those from the popular Billingham range are well padded, have useful dividers and don't shout 'cameras inside'.

If you've been well and truly bitten by the bug it can be sensible to invest in two bags. One is the big, cavernous one that can take all your kit to that special event or assignment. The other, more compact, would be ideal for the weekend away or when portability is crucial.

Camera bags: look for
- good levels of padding
- plenty of compartments
- good access
- good weather protection
- option of straps for attaching tripod or monopod.

Tripods

If there is one thing that characterizes amateur video (and cine before it) it is camera shake. That vibration (due to involuntary hand movements) which becomes more pronounced as a zoom lens is used makes for uncomfortable viewing. Fortunately, camera manufacturers have recognized the problem and built image stabilizers into many models. These do a great job in overcoming most shake but don't make up for having a stable platform in the first place.

The best way to make sure that your video camera is rigid is to use a tripod. These come in a wide range of styles, sizes and strengths. The most important feature when you are auditioning models is rigidity. Can you mount your camera on it without it shaking – something that can afflict cheaper models? A rigid tripod need not be heavy: composite materials are used in many designs and produce a lightweight – if bulky – choice.

After rigidity, the next feature in importance is the head: the section on which the camera is mounted. You generally have a choice here between ball and socket and pan and tilt. Ball and socket heads are ideal for still photography. They let you point a

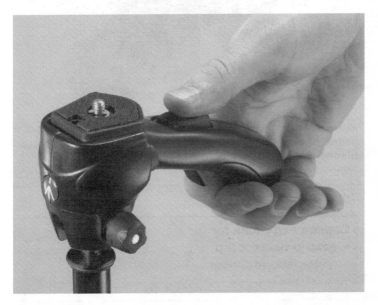

figure 3.3 pan and tilt: this pan and tilt head features a push-button control to release the mechanism for positioning the camera.

camera in any direction quickly and lock it in place. For video photography you are less likely to want to point your camera in unusual directions but more likely will want to track around the horizon. Or move upwards to take in, say, a tall building. These are the motions offered by a pan and tilt head. You'll find that the more you are prepared to spend the smoother the panning and tilting will be. Some tripods come complete with a head whereas other tripods let the owner choose a complementary head.

figure 3.4 heavy-duty pan and tilt: this more substantial pan and tilt head features graduated axes to make positioning precise. It is topped-off with a spirit level that ensures the tripod can be set up horizontally.

Tripods: look for
- lightweight
- rigidity
- convenient height
- pan and tilt head
- smooth motions.

Supports

If you are serious about your movie making you'll need to have a tripod in your equipment arsenal. There will be times when you can't take a tripod with you or the locations you are shooting in don't allow tripods. Many building interiors restrict or forbid tripods on safety grounds, for example.

So how do you get steady shots in these circumstances? One solution is a monopod. Ostensibly a single leg tripod (that is, a collapsible leg with a pan and tilt head at the top), a monopod relies on you, the video photographer to provide rigidity, using your body to complete the tripod. It won't be as rigid as a tripod, nor is it freestanding, but it's more portable and will successfully give you those steady shots where tripods fear to tread.

figure 3.5 monopod: much more compact than a tripod, this monopod sports a ball and socket head. Though not ideal, it makes for a more compact package.

Even more portable than the monopod is the minipod. Measuring just a few centimetres in height these are designed to be mounted on a convenient ledge, chair or other prop. They are great for slipping into your gadget bag or pocket for use just about anywhere when you need that little bit of extra support.

figure 3.6 like a tripod, only smaller: minipods are often pocketable yet give adequate support where space is tight.

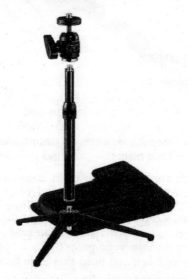

figure 3.7 variation on a theme: how's this for some lateral thinking? Add three fine legs to a monopod and you've a reasonably stable, freestanding tripod.

Beanbags make a great alternative to the minipod. They cradle the camera – again when provided with a suitable prop – and are easily carried just about anywhere.

> **Supports: look for**
> - compactness
> - portability
> - rigidity.

Power

Batteries are often sold and promoted as accessories, but as we mentioned in the last chapter, these are better considered as essentials. Don't forget either that you'll need a means of charging your batteries. Many batteries can only be charged in-camera which is neither convenient nor desirable: it means that you can only charge your batteries when the camera is lying otherwise dormant. Equip yourself with an external charger and you can charge – or top up – a battery when shooting with another. Getting a charger with a car-charging option gives you even more flexibility if you are caught short – in power terms – during the day.

Microphones

Another characteristic of the professional filmmaker is the huge microphones, usually cloaked in a wind-cheating sock (that fluffy, rabbit-like covering). Does this put us, with our cameras sporting much more discrete microphones, at a significant disadvantage when it comes to recording sound? Yes and no. Let's explain a little further.

Though the microphones in most consumer camcorders are very small, they are actually remarkably adept at picking up good quality sound. Unfortunately, by their nature (and by virtue of their position) they are equally successful at recording all sounds – the ambient sound (all that going on around the camera including traffic, birds, passers-by) and even the self-noise generated by the camera. Tape mechanisms and zoom lenses make characteristic noises that are adeptly recorded via the onboard microphones. So for the best – or better – quality sound we need to consider an auxiliary microphone.

Camera stores can tempt you with several different types, so which is the best to go for? For general use a model that mounts on the camera (using the camera's accessory shoe – the small mount at the top similar to that used to mount flashguns on still cameras) is best. These are easily slipped on or off as required and some models – usually those designed by the same manufacturer as the camera – often connect using contacts in the accessory shoe which saves the need to connect separately.

figure 3.8 clip-on microphone: if you plan to conduct video interviews or vox pops, a clip-on microphone provides a discrete way to record a speaker's voice without an obvious microphone in shot.

Accessory microphones let you record sound from the area in front of the camera (generally that involving the subjects of your movie) and restrict, or eliminate, sounds coming from different directions. Zoom microphones let you 'zoom with sound' so that you can restrict the sound recorded to a progressively smaller area in front of the camera as you zoom.

Headphones

You're not going to need these when filming your family's day out at the theme park, but if sound quality is crucial to your production you're going to need some way of checking that quality and monitoring the recording. Small earbud earphones like those for an iPod are compact and pocketable but, unless

you go for the stratospherically priced models, won't be able to keep out ambient sound. A better option is a good pair of closed-cup headphones (those that enclose your entire ear) that do a good job of keeping out extraneous sound and let you concentrate on the recording.

figure 3.9 headphones: though larger than many offerings, closed-cup headphones like these will cut out most external noise and let you concentrate on that being recorded.

Going underwater – or to the beach

Video cameras may be robust, but they can still fall victim to the twin evils of water and sand. If you expect to do much shooting on the beach, near a swimming pool or if water sports are your forte, you'll need to take special care to keep your camera in pristine condition.

The best solution is to equip your camera with an underwater housing. Generally built of optical quality Perspex, or featuring an optically transparent window for the lens, underwater housings will let you operate most, if not all, of your camera's controls when enclosed. In fact the housing controls are designed to be operated underwater even by someone in a wetsuit. The drawback with these housings is that they are model specific and pricey. If you plan to shoot underwater or in sandy conditions it's worthwhile checking that there is a housing available for your prospective camera.

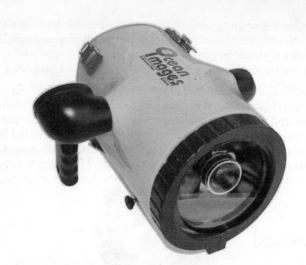

figure 3.10 underwater housing: solid, robust and watertight, underwater housings can be expensive but are a worthwhile investment if you're heavily into water sports and diving.

figure 3.11 Aquapac: surprisingly robust, Aquapacs conform to the shape of your camcorder and provide an economic alternative to underwater housings for occasional use.

If there isn't a housing for your camera, all is not lost. You can equip yourself with an Aquapac. These are nothing more or less than robust plastic bags into which you drop your camera. A watertight closure ensures your camera is properly protected.

The benefits of the Aquapac are that there are models to fit just about every camera, they are more compact than custom housing and, should you change your camera, you can use it with your new purchase. The down sides? The plastic of the bag may not offer the same transparency as the custom housing and controls may be a bit more fiddly to operate. However, for most of us who would only have a casual need for waterproof housings, the low cost is an ideal antidote!

Digitizers

Some of us have vast – or maybe modest – collections of old, analogue videotapes from which we might want to produce some digital video productions. We'll look much closer at this topic in Chapter 14 but it's useful to bear in mind that if you intend to do so, you'll need some method of converting analogue video into digital. That method involves a gadget called an analogue to digital converter, or **digitizer** for short. This is one of those proverbial black boxes. We don't know what happens inside – and don't need to know – but we plug in a source of analogue video in one side and out comes digital video at the other, ready to be fed into our computer.

If you're in that fortunate position of having some valued video archives and want to add a digitizer to your set-up you'll find these devices are not expensive – a fraction of the price of a new camera or about the equivalent of a middle-range tripod.

Photographic accessories

In still photography filters can be placed over the lens to modify the image entering the lens. Sometimes this modification is in colour or tone – for example, the warm-up and cool-down filters used to compensate for changes in lighting through the day. Many of these filters are also suitable for video photography. Let's take a look at those which you are most likely to come across.

figure 3.12 polarizing filter: a polarizer is probably the most useful accessory filter. Unlike other special effects, the reduction in reflection and increase in colour saturation is hard to duplicate using post-production techniques. It also reduces glare, as shown here.

Polarizing filters

These are used to reduce reflections and boost colour saturation. A very useful filter for sunny days. Make sure you purchase a circular polarizer rather than the (often cheaper) linear polarizer. Though they look the same, linear polarizers can interfere with the operation of the video camera's metering and focusing systems.

Skylight and UV filters

These are apparently transparent pieces of glass that are often touted as a way of protecting the valuable front surface of your camera's lens. Some can produce a modest reduction in haze. Some critical users suggest that, because they introduce additional optical surfaces into the light path, they should be used sparingly.

Colour correction filters

These are used, as we've mentioned, to alter colour casts and tints. The white balance control on video cameras can make these obsolete unless you want to introduce colour for creative results. Corrections can also be made later using controls in your video editing software.

Graduates

With tinted tops and clear bottoms these filters are used to even out differences in brightness between the sky and land in landscape shots. In pro movie making these are considered essential in many shots. In our movies where the camera is likely to be hand-held a lot of the time (and so would betray the presence of the filter) it is less suitable. Still, if you have some in your stills photography kit bag, keep one or two at hand – though you may need a different (or new) adaptor to attach these – or any lens accessories – to the smaller barrel of your digital camera's lens.

Special effects

Digital video cameras and video editing software can apply countless special effects to your movies. Some are useful, many less so. The trouble with using special effects photo filters (such as starbursts, spectrums, colour bursts and even rainbows) is that once committed to tape (or disc) they are there for good. The same is true of in-camera special effects, so the best advice is – unless you have reason to do otherwise – apply special effects in the software. That way if you don't like the effect or want to change it, you can.

Lens hoods

Flare is a problem for all cameras. The sun and other bright lights can reflect internally between all the glass elements that comprise the camera's lens – even if the light source is not actually in the field of view – causing a lowering of contrast in your shots or, worse, streaks and patches of light across the scene. A lens hood can reduce – if not remove – the likelihood of flare at a stroke. Accessory hoods are available from most of the accessory vendors, but a model specific to your camera will probably give the best results. Generic lens hoods can cause shadows when the zoom is set to wide angles.

Summary

Before buying any accessories here are a few things to consider …

- Be ruthless with your accessory wish list. Justify every purchase, otherwise you'll either be carrying around dead weight in your gadget bag or left staring at an expensive but little used ornament.

- A good support is essential. If your style of photography or subject matter doesn't allow tripod use, invest in a minipod, monopod or even a beanbag. Anyone viewing your movies will appreciate it.

- A good bag will not only protect your camera but make it easy to carry it and some choice accessories around all day.

- Sling bags are particularly convenient if you are using your camera frequently – they allow you to delve into your bag and then sling it on your back without ever taking it off your shoulder.

- An Aquapac is a sensible investment for any holiday involving beaches, deserts or dusty places; avid divers may want something more robust.

04

computers and movie-making software

In this chapter you will learn:
- what we need to create a desktop movie editing studio
- about the essential hardware and software required
- what the hardware requirements are for incorporating older analogue video in our productions
- about enhancements which can help make movies even better.

If you've ever seen one of those 'Making of ...' documentaries about blockbuster movies you'll have seen the editor-in-chief (that is, one of the army of editing staff involved in the film) talking. Surrounded by banks of computers, computer screens, projection systems and racks of film cans, he (or she) will be extolling how the latest and greatest kit has been used to get the very best results.

Creating a desktop movie editing studio

You'd imagine that movie editing was a complex task that demanded first rate resources and first rate personnel. And, of course you'd be right – certainly with regard to the major studios where nothing short of absolute perfection is permissible. So are we, with our more modest equipment and meagre resources, disadvantaged? Actually, no. You'll be surprised how effective a simple, desktop editing suite can be, an editing suite built around our humble home computer.

Your computer as movie editor

In fact, it's doing the technology a great disservice to describe it as 'humble' because even the most pedestrian of computers today can offer performance that, just a handful of years ago, would be considered top-flight. Truth is, most computers today will be remarkably adept at handling digital video editing. And, given a little boost, they'll really fly.

Video editing applications do tend to be demanding in what they require from a host computer. If you have an older computer or have concerns that your machine may not be up to the job take these specifications as useful guidelines. As a good rule of thumb, for standard video editing the minimum specification you'll need for your computer is Pentium III running at 500MHZ or better if you are a Windows user, or a G4 if you're a Macintosh user. In either case, the respective computer will need to have 512MB or RAM as an absolute minimum and a large hard disc with as much as possible free space to use. Digital video processing needs as much memory as you can provide (so double the above figures is desirable) and the amount of data downloaded from your videotape (or disc or card) is prodigious and will rapidly use up gigabytes of hard disc space.

In fact, if you are a Mac user you can be pretty sure that your computer will run video editing software as virtually all Macs since 1999 have come bundled with the highly regarded iMovie (of which more later), attesting to the machines' abilities.

To be honest, if you've bought any computer in the recent past it will probably give you all you need. Of course you can refine your computer with selected peripherals, but for your early adventures the standard machine should suffice.

One note of caution: when you're evaluating different software products beware of the description on the box (or maybe the website) of 'minimum specifications'. These describe the minimum requirements of a computer to run the software. This is even more applicable to digital video editing software when computers of minimum specifications will struggle to perform and ultimately will deliver less satisfactory results. It's better to pay attention to the higher recommended specifications.

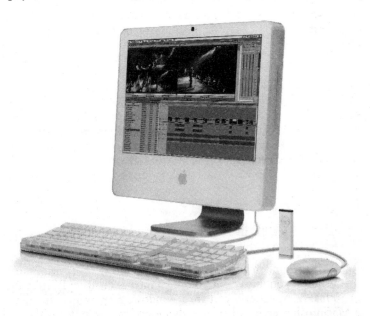

figure 4.1 desktop: desktop computers with large screens are particularly suitable for video editing and avoid eyestrain.

FireWire

The only point at which a PC may let you down is in connectivity. To connect your computer to a digital video camera you need a FireWire connection. Sometimes called **iLink** (particularly in the world of Sony) or less glamourously **IEEE 1394**, this is a high speed connection that provides optimal connectivity for digital video cameras. This is purely a PC issue as Macintoshes have been compliant in this respect for some time, and does not apply if you download footage using a DVD or memory card.

So if your computer is perfect in every other respect but just lacks a FireWire socket, will you have to resign yourself to a new machine? Not at all. If you've a desktop PC you can buy – cheaply – FireWire cards that can be fitted easily in one of the bays within the computer. If you don't feel confident about doing this yourself, most of the well-known high street electronics stores will fit free of charge or at a nominal cost.

Laptop users can buy FireWire PC cards that can be slid into the PC card slot to provide the right functionality. And with these it's usually plug and play.

Where PCs do offer FireWire connections these are generally of the smaller four-pin variety rather than the six-pin found on Macs. This is of little consequence for our purposes – the two additional pins provide power to drive the connected device. As our connected cameras will be running off batteries or a mains connection the additional pins are superfluous.

Laptop or desktop?

We've seen a terrific increase in the power of computers over the last few years and this has been particularly marked in the field of portable computing. Laptops today can pack a punch that would put many a desktop to shame. So, if you were about to ask if there were any handicap in using a laptop the answer now would have to be a resounding no! Assuming all the other criteria (for memory and disc space, for example) were met then it comes down to personal preference and – if you are shopping for a new machine – budgets.

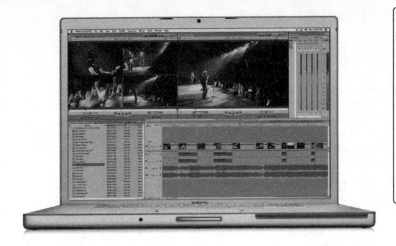

figure 4.2 laptop: laptops today sport plenty of power, more than sufficient for video editing, and they have large screens, too.

Computer add-ons

With your computer in place the inevitable question is 'what else do I need to complete my editing suite?' In practise, you'll need very little else. Should your editing needs be modest then it's possible you'll need nothing further. As your aspirations grow so will your needs. Let's take a look at the key add-ons that will make your video production even more potent.

Monitors

We'll assume that your existing computer system already boasts a monitor. Will it be sufficient? Unless it is particularly small, yes. However, video editing software becomes easier to use on a larger monitor. Consider a 17-inch monitor the smallest usable size but, if funds allow, a 19- or 20-inch screen will be easier to work with.

Disc drives

Downloading video from a camera produces huge amounts of data, as we've already noted. In fact an hour of DV footage can consume 12GB or more. Once you start editing, rendering and

building DVD compatible material, a large hard disc can quickly be consumed. Having an additional disc drive makes good practical sense. This could be a second drive mounted in your desktop machine (added in the same way as a FireWire card) or could be an external drive. External drives – which should be connected using FireWire or USB 2 to sustain the huge data transfer speeds – are the easiest to use as they only need a connection to your computer and are ideal for laptop use. Buy the biggest capacity you can, and reserve its use for your digital video projects to make writing to and from the disc as swift as possible.

DVD, Blu Ray and HD DVD drives

Many computers today, both desktop and laptop, come equipped with DVD burners so that you can edit your video and burn a DVD of the result. If yours doesn't, external drives are easily available and connect in the same manner as an external disc drive. As high definition video becomes increasingly prominent expect to see higher capacity Blu Ray and **HD DVD** drives appear. These will also connect in exactly the same way and are a perfect way of breathing continued life into a computer that's otherwise still delivering of its best.

figure 4.3 HD DVD drive: external drives give you the flexibility to master your movies – should you wish – to new formats such as HD DVD.

Analogue to digital converter

More often know as an **A to D converter** or simply a digitizer, this is an often overlooked but incredibly useful device. You can feed in analogue video sources at one end and have digital video – or a digital video signal – drop out the other. In practise this means that you can connect your old VHS or Betamax video recorder, VHS-C or Video 8 camcorder to the input and import digitized video into your video editing software.

This is perfect for making a DVD, say, from video recordings that you might have made decades ago. It's also possible to feed analogue television signals into the device and produce digital recordings. Not quite as convenient as a digital tape recorder but certainly capable; and because you can import this footage into your editing software you can manipulate the source material – cutting out commercial breaks for example – before committing to DVD. We have more to say about using digitizers in Chapter 14.

figure 4.4 digitizer: this compact digitizer from Dazzle connects using USB 2 for downloading analogue video or television.

Essential software

Of course a computer, no matter how powerful, only becomes a video editing tool when equipped with appropriate software. The software harnesses the power of your computer and allows you to import video, edit at will and export to your chosen medium. Software packages tend to align themselves into categories that we've described as Basic, Intermediate and Advanced. We need to provide a little explanation here.

Basic packages are those that are simple to use: there's no compromise in the quality they offer. You'll be able to make some impressive movies with these, very quickly. They are distinguished from the more advanced packages only in the degree of fine control that they offer and are limited in some of the fine control. To be honest, when you are producing movies of holidays and family events, the ability to deliver results fast will be more important than multichannel sound mixing and fine levels of colour correction. It will be software from this category that we'll focus on in the following chapters.

When those – and more – features do become important, Intermediate level applications can give you the power to deliver finely crafted movies without resorting to the complex (and expensive) professional level applications. This category is relatively new and born from the need to satiate increasingly expectant enthusiasts.

Advance applications are the real no compromise workhorses that the serious enthusiasts will relish. And they will be in good stead because these applications are those used by professionals and the major TV companies. There's nothing that you can't do with these – but it'll be a sharp learning curve to get to grips with every opportunity that they offer.

Let's take a look at some of the software offerings in these categories. It's not an exhaustive list but will give an idea of the range available. Endorsements? It's fair to say that of all the applications here – and those we've not had a chance to list – there's not a poor performer among them. Your choice will, most likely, be determined by personal preference. And to make that choice more informed, most of the applications here, if not preinstalled on your computer are available as trial downloads. We've given the contact details in the 'taking it further' section at the end of this book.

Basic applications

Apple iMovie

Perhaps the package that every Mac user has, or will use to edit their first movie. The basic but effective package has been bundled with most new Macs for some years and is also available – in the most recent version – as part of the iLife package. The key benefit of iMovie for Mac users is its compatibility – plug in a digital movie camera and you're ready to go. Tight integration with other elements of iLife such as iTunes and iPhoto makes it easy to pull in audio tracks and photos and export the results to iDVD for professional looking DVD production.

Windows Movie Maker

The Windows equivalent of iMovie is Windows Movie Maker and boasts a similarly simple interface. Again it's based on basic plug and go principles, letting users quickly download video and start editing. The package is more rudimentary than most of the Windows compatible offerings in this category, but is still capable of good results. And, as it's a freebie, who can complain?

Adobe Premiere Elements

If you find Windows Movie Maker doesn't give you all the features and functions you'd like and you want something a little more substantial, Adobe Premiere Elements will fit the bill. This is a trimmed down version of Premiere, the staple of many serious video movie makers. Like many of Adobe's trimmed down products the greatest trimming seems to be of the price whilst in functionality terms it's only the top level features (most prized by the pros) that have been removed.

Ulead VideoStudio

Ulead have a comprensive range of video software, and VideoStudio is its key editing package. Like iMovie it has a clear, easy to use interface with a wide range of options for titling, producing transitions and special effects.

Arcsoft VideoImpression

Another very clear, easy to use product, this time from the Arcsoft stable, VideoImpression uses a step by step approach to building a movie. This is great for newcomers who can move from stage to stage and be guided through every step.

figure 4.5 iMovie, Windows Movie Maker, and VideoImpression: though the details differ, these three basic packages feature a very similar layout and structure. The emphasis in each case is on ease of use and simple workflow. The screen view is very much uncluttered compared with higher level applications but this works to our benefit, allowing us to concentrate on the essential tasks involved in producing a movie.

Intermediate and advanced applications

Apple Final Cut Express and Final Cut Pro

Apple's strength in the basic video editing field is echoed in the intermediate and advanced arenas with Final Cut Express and Final Cut Pro. The latter has become the indispensable tool of the pro video editor. Its cut down version, Express, is an ideal stepping stone from iMovie and will provide many users with all they will ever need.

Adobe Premiere

The parent of Premiere Elements gives Final Cut Pro a good run for its money and can satiate the demands of intermediate and advanced users. In the same way that iMovie integrates with other iLife applications so this integrates with many of the Adobe stablemates further extending the functionality and capabilities. In fact, Adobe includes Premiere in its Video Collection package which also features special effects exemplar After Effects, DVD creator Encore and the ubiquitous image editor, Photoshop. Incredible power, but at a price!

figure 4.6 Premiere: the serious credentials of Adobe's Premiere are illustrated in this typical screen. There's sufficient control on offer to satisfy the most demanding editor.

figure 4.7 Adobe Video Collection: Premiere is also at the core of Adobe's Video Collection.

Other names to look for? Sony Vegas Video, Avid Xpress DV and Xpress DV Pro are just some of the applications that you'll find in the rarified atmosphere of the pro world.

Software compatibility

As we've already mentioned it is important to check that your chosen application is compatible with your computer. That's not just a matter of ensuring that it will run on your machine but also that it will run well. Remember what we said about minimum specifications earlier? Make sure that your computer conforms to the higher recommended specification.

Bear in mind, too, that if you are using – or plan to use – cameras that produce high definition video you'll need to check that most applications will be compatible with the format. Most are, but a double check will not go amiss.

Beyond video editing applications

Once you've settled on a video editing application you're ready to start producing some great movies. Is that all you'll need? To create movies yes, but if you want to, say, produce a DVD or master a video for distribution on the web you might need something extra.

We've mentioned that iMovie users can output to the companion iDVD and seamlessly create DVDs with just a few keystrokes. In the Windows world you've similar products (such as Roxio's Easy Media Creator and Arcsoft's Showbiz DVD) or you could opt for an all in one package – capable of video editing and producing DVDs and other media – such as Ulead's MediaStudio Pro.

As your editing prowess expands you may find that the basic functionality of your video editor leaves you wanting in a number of areas. If – or when – that becomes the case there's plenty of opportunity to extend the scope. Applications abound for the creation of special effects (Adobe After Effects being a good example), advanced sound manipulation and recording and even the creation of jaw-dropping graphics.

Summary

- Video editing makes reasonably heavy demands on a computer so a well specified machine is desirable but not essential.
- If shopping for a new computer, make sure the spec is up to the requirements of video editing applications and exceeds them wherever possible.
- If using an existing computer, consider upgrading the RAM memory to at least 1GB and investing in an additional internal or external hard drive. Your favourite computer store can advise and install this for you, if required.
- Audition software before purchase. Functionality may be the same for most basic applications but approaches and details do differ.
- Even if money is no object, if this is your first foray into digital video a basic application is a good place to start. More advanced applications could prove baffling until you develop a good understanding.

- If you are planning to produce DVDs or distribute your movies on CD make sure that the software you're considering includes these abilities. If not, take a look at products that will add this functionality.
- Into HD video? Make doubly sure that your computer will be up to the mark and that the software will handle it.

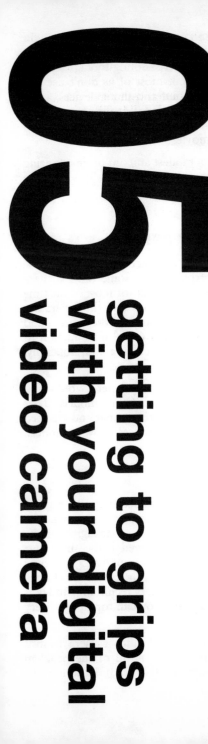

05

getting to grips with your digital video camera

In this chapter you will learn:
- the key components of your camera
- how to take the first steps in using it
- how to best look after your investment.

Digital video cameras are easy to use. You can take one straight out of the box and, assuming you have had the foresight to charge the all-important battery, start shooting footage straight away. It's something of a shame but most of us don't use our cameras as anything more than point-and-shoot devices. It's a shame because, with just a little knowledge of the controls that lurk under the camera's proverbial skin we can do so much more and create much better movies.

In this chapter we'll spend just a modest amount of time touring the camera and getting to grips – sometimes literally – with the controls and features on offer.

A guided tour of your camera

You can understand some people's reticence in getting to know what all the buttons and controls do: on some models there seem to be so many! The good news is that for most of the time many of these controls will be superfluous and the others are pretty obvious in use. Let's take a look around the camera and explore the key controls. This will be a useful introduction to those picking up their first digital video camera and, hopefully, a useful aide-memoire for the more experienced.

Though there is no definitive layout for a camera, you'll find many controls in similar positions on different models. That makes it easy to swap from one camera to another and we need only be aware of the sometimes subtle nuances between models.

We have power!

For reasons of safety, practicality and expediency, the battery supplied with a new camera will only be partly charged. The advice – often given loud and clear on the packaging of the battery – is that it should be fully charged before use. Our advice? Have a little play with your new purchase first (you can't resist it really, can you?) and then set the battery to charge. This should take only a few hours – battery technology today is such that chargers can charge fast and you can top up a battery at any time.

If you have graduated to a new digital video camera from a vintage analogue model you may be mindful of the problem with the supplied Nickel Cadmium (Ni Cad) batteries: the

figure 5.1 camera battery: mounted (usually) at the back of the camera makes it easy to replace your depleted camera battery with a freshly charged one.

dreaded memory effect. This defect meant that, unless you fully depleted the battery of charge before recharging, the battery would fail to fully charge on the next charge and result in deteriorating performance. All sorts of contrivances – such as discharging circuits built into chargers – were offered but battery performance would quickly become mediocre. Many a video recording was lost as batteries died on their owners.

Modern Lithium Ion (Li-on) batteries and other technologies don't suffer these problems so don't be afraid to top up the charge at any time. You'll also find the capacity of the batteries versus their size is much better than it used to be. However, as we've said earlier, camera manufacturers seem loathed to supply high-capacity batteries with their cameras, partly because they would be more expensive and partly, with an eye to the statistics, their larger size would impinge on the quoted size and weight of the camera!

It makes very good sense to invest in a second, and possibly third, battery. If these are high-capacity models you should find that, with them all fully charged prior to any assignment, you'll have ample power to keep shooting throughout the day. The first time you use your camera you'll find out how quickly the battery is consumed and can then budget for how much power – and how many batteries – you will ultimately need.

Loading the media

After charging – and fitting – the battery (and note that some models have a second battery – usually a tiny one of the type found in watches, hearing aids or some children's toys – to retain time, date and settings information), you need to load the camera with the appropriate blank media so that you can start shooting. Of course, if your camera features an inbuilt, non-removable drive or solid-state memory you can happily skip this section.

Though other formats are vying for precedence, tape is still the most common media type. If you've a tape-based camera you'll find the tape compartment on the side of the camera or, less commonly, the base. A light press on the 'eject' or 'open' button will set in motion a few seconds of whirring and buzzing as tiny servo motors prepare the tape compartment to disgorge any tape inside or to accept a new one. It can be a disconcerting sound for a newcomer to video cameras but rest assured, it's quite normal.

Once the sounds have come to a stop the compartment will be open and ready – if empty – to insert a tape. Slip it in (usually flap first) and close the flap. The mechanism often features a 'push here' panel that will start the closing process – the reverse of the opening. Take note of any parts of the mechanism that say 'Do Not Press This Part'. Pushing or prodding this part of the mechanism could cause damage.

figure 5.2 tape loading: once the tape chamber is accessible, you can slip in the tape and close the chamber. Take note, however, of any warnings about parts that should not be pressed!

If your camera uses DVDs the process is basically the same as for tape, except you'll hear fewer noises during the open and close process. Place the disc, writing surface towards the camera body, into position and then close the door.

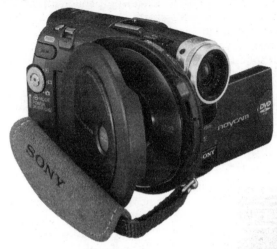

figure 5.3 DVD chamber: select the Open or Eject button on a DVD camera and the chamber door will open allowing a used DVD to be removed or a fresh one inserted.

figure 5.4 memory card: this DV camera also features a memory card slot for the storage of still images, contained behind a flap under the LCD panel.

To load removable media cameras (such as those that use Compactflash or SecureDigital (SD) cards) you can slip the card in or out, using a push button (or pushing the card itself) to release. It's wise to turn the camera off first. The same applies if you are using a DVD or tape-based camera that features a memory card for the storage of still images.

Turning on

With media loaded, batteries ready to unleash their power, you're all set to begin recording. You can turn on your camera using the mode selector, a simple control that, when you hold the camera ready to record, falls under your thumb. This will have basic modes of Off, Camera and VCR (or sometimes Movie).

The Off mode is self explanatory – and it's a good idea to return the camera to this in between shooting to conserve power. In camera mode your video camera is ready to record. The LCD display and/or viewfinder will display the view though the lens ready for you to compose your first shot. If the screen appears blank it probably means you've left the lens cap – or lens protector – in place. Now, when you press the record button – often incorporated into the mode selector – you can begin shooting. Press the button again when you want to stop.

Switch to VCR (or Movie) mode and you can review the footage you've shot. To scan through your recording you'll need to use the video transport controls, a set of controls that you'll be familiar with from your conventional VCR: Play, Pause, Fast Forward and Rewind. On some cameras these are ranged below the LCD panel (which changes mode from displaying live footage to displaying recorded), on others they are mounted on the camera body. Some models feature 'soft keys', keys that appear on the LCD panel only when the VCR mode is selected and are activated by touching the screen.

If – like me – you are left-handed, you may be concerned that all camcorders, save for a few ultra compact **MPEG-4** machines, are designed for right-handed use. You'll be surprised, though, that you'll soon find that you don't need particular dexterity to operate the camera with your right hand and you won't be at any particular disadvantage.

Some mode selectors include additional functions. Rather like stills cameras you can find specific shooting modes (for example, for action or sports photography) that configure the camera for

specific shoot types. You may also find that there's a still shot mode included on this control. Set this and the record button becomes a shutter release, recording a photo on each press.

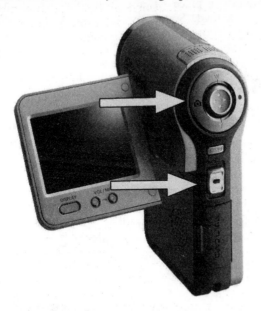

figure 5.5 mode selector: on this Samsung model the switch control (lower arrow) selects the mode while the multifunction rocker (upper arrow) is used for recording (and for still image shooting).

figure 5.6 shooting modes: the dial on this Canon camcorder allows the selection of specific modes when shooting still images and mirrors the mode selector provided on the company's still cameras.

Viewing and data displays

When, a few years ago, Sharp introduced an LCD panel on its Viewcam range in place of a conventional viewfinder the industry was divided. Some saw it as the future, others a backward step. Those who saw it as a step back cited the inability to view an LCD panel in bright light, rendering the camera difficult – if not impossible – to use in such circumstances. Since then LCD technology has improved (particularly with regard to brightness and visibility) and Sharp's foresight has been acknowledged across the industry.

In fact, many manufacturers recognize that though useful, the LCD panel is not perfect in all respects and also provide a conventional viewfinder. This gives you a useful back-up for when the daylight is exceptionally bright and (perhaps in more practical terms) greater longevity in shooting. A viewfinder consumes somewhat less power than an LCD.

The benefit of an LCD is that it allows you to shoot with the camera away from your eye. You can shoot at ground level, over your head or even around a corner by angling the panel appropriately.

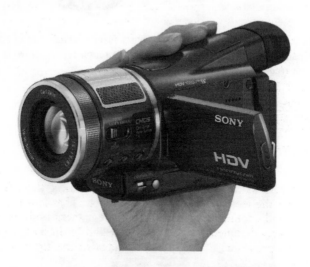

figure 5.7 LCD display: the chief benefit of an LCD display is that you can use the camera in any position that is comfortable and still get a good view of the monitor. Tilt and swivel action also makes it possible to put the camera in positions where a traditional viewfinder would be inaccessible.

As well as the means of composing, monitoring and reviewing shots the LCD panel is also our principal source of information when using the camera. Superimposed over the image can be:

- the battery condition
- time used (or time remaining) on the current tape or disc
- the length of the current shot
- sound recording information
- zoom lens information
- playback information (when replaying)
- time and date.

This can be an awful lot of information and can prove distracting so you can usually chose to hide this information when you want to concentrate on composition.

It's important to note that much of this information is also recorded on tape – but not visibly on each frame but invisibly, encoded digitally within the digital video signal. This means that you can copy the tape, edit it and still recall pertinent information later.

As well as this basic information, activating some of the secondary controls on the camera – such as selecting special effects – will call up an on-screen menu from which you can choose the selected function. Or you can modify the shutter and exposure settings, if your camera permits this.

Those using some DVD and hard disc-based cameras will find that the LCD panel also lets you perform simple editing: you can re-sequence shots, skip others and even add in-camera titles.

Lenses

Though it is wrong to single out any single component of the video camera as being crucial to the image quality, there is no doubt that the lens is very important indeed. That lens can be compact and contained entirely within the camera body or, on those models designed for the semi-pro and enthusiast, much larger and providing a weighty appendage to the front of the camera.

figure 5.8 interchangeable lens: semi-pro models feature interchangeable
lenses for ultimate flexibility – at a price.

Some models – in a minority admittedly – offer interchangeable
lenses much in the manner of an SLR stills camera. This
provides the user with the opportunity to use lenses that are
ideally matched to the subjects they want to photograph. You
can even select specialized lenses – such as macro lenses for
close-ups – for specialized applications.

For the rest of us the fixed mount zoom lens provided with the
camera provides coverage for virtually all everyday situations.
Few cameras allow you to directly control the zoom lens
manually; instead you'll find a rocker switch that in one
direction zooms out and in the other zooms in. This control is
usually close to the main record button, allowing the same
thumb (or finger) to operate both.

Though the rocker is useful it does tend to lack ultimate control:
you'll find it hard to control the speed of the zooming (which
can be a problem when shooting and zooming). Getting your
scene precisely framed can also be difficult as even a light action
on the rocker can cause the zoom to jump by discrete amounts.

Remember, too, that the digital zoom – boasting ratios of 100x,
200x or even more – is of little practical value: only the optical
zoom (often a more modest maximum of 10x) will provide you
with good image quality.

figure 5.9 zoom control: centrally located on this Xacti camera, the zoom rocker lets you adjust the zoom lens with fingertip action.

figure 5.10 optical zoom: compared with the digital zoom ratios, optical zooms sound rather pedestrian, but the quality will be far superior, especially when used with high definition formats.

Lens cap and filters

Like all optical surfaces your lens needs to be treated with respect and kept clean. It makes good sense (and is good practice) to keep the lens cap on whenever the camera is not being used. Some people use optically clear UV or Skylight filters (page 44) to protect the lens. The camera is then always ready for action and the lens surface is protected from the ingress of dust (and, of course, replacing a filter is much cheaper than repairing the lens).

Whatever your preference – filter, lens hood or bare lens – it is essential that you keep your lens (or filter) spotless at all times. A fingerprint or specks of dust can seriously reduce contrast, and lead to poor image quality.

Use a soft blower brush to remove light dust and contact marks and lint-free cotton cloth (or specially designed microporous cloths) for more stubborn marks. Though never recommended in any of the camera manuals, a clean corner of a cotton shirt can be pressed into emergency service when other cleansers are unavailable.

Protection

If you ever have the opportunity to see the innards of a digital video camera you'll probably be surprised at how much concentrated electronics and mechanicals there is contained within. Suddenly the prices charged seem like an absolute bargain! These devices are also remarkably robust and can give years of trouble-free service. Like any electronic equipment you need to keep your camera away from:

- excessive heat – including car interiors on hot days
- direct sunlight (which can warp and distort components)
- damp
- high humidity
- particulate matter – including, but not limited to, dust, sand, pollen and smoke
- magnetic and electromagnetic fields – don't leave your camera standing near your computer's CRT monitor (if it has one), TV or audio speakers
- knocks and shocks.

You should be mindful of all these factors but not obsessed with them. In day-to-day use you'll keep your camera safe in a well padded bag or pocket and avoid extremes of weather. And, should you venture to the beach or into the water, ensure you take on board our advice earlier about underwater housings and Aquapacs.

Summary

Okay, so there's more to a digital video camera than we've discussed here, but we've distilled the key attributes so you should now be able successfully to shoot some basic video footage.

You'll be aware now of:

- the importance of keeping fully-charged batteries and the advantage of investing in additional ones
- how to insert and replace media – should that be appropriate for your model
- the fundamental controls that let you power up the camera, select record or playback
- how the viewing systems work and the information they present
- how to use – and care for – your camera's lens
- some basic care and maintenance.

This should have given you that bit of confidence – or extra confidence – to start shooting in earnest. And as we take our first steps we'll explore good shooting technique, the key subject of the next chapter.

06

**creating your
first movie**

In this chapter you will learn:
- basic video techniques
- about composition
- about different video shot
 types
- how to create a script and
 storyboard your ideas.

Back in the early days of the movies it was sufficient to impress an audience by showing a succession of moving images. The novelty value compensated for the rather prosaic nature of the actual scenes. The early pioneers soon realized that to maintain the interest of the audiences they needed to tell a story and that a structured and logical approach was needed.

So the craft of cinematography was born and it's a craft from which we can learn some useful lessons. There are really two essentials for creating great movies. One is getting raw footage that we can ultimately use to tell our own personal stories. That's something we'll take a look at shortly. The other is gaining that understanding of good movie-making technique. Good technique is crucial to producing a good movie and it's something that comes as a result of both a methodical approach and experience. We can't teach experience but we can take a look at technique. In this chapter we'll examine the fundamental rules of composition and shot types and then look at how we can use this knowledge to help when scripting and **storyboarding** our movie.

Understanding composition

Turn the pages of any photographic manual and you'll find chapters devoted to composition. Indeed, there are an ever-increasing number of tomes devoted to this subject alone. Composition is just as important in video photography as still and, usefully, many of the same rules apply.

Image composition is about the placement of elements within a scene to best effect. It is also concerned – especially in video photography – with the interaction between different planes in the scene: foreground, background and subject.

Composition does often seem beset with rules with exponents defining the perfect or ideal composition for every situation. Those that are so keen to promote these rules often seem to spend their time breaking them. In truth there are no hard and fast rules that we should be mindful of following to the letter but there are compositions that seem to work better than others.

The Rule of Thirds

If there is one that 'works' more than others it is the Rule of Thirds and it is one that is easily learnt and just as easily exploited. It does, however, require us to break free of our instinctive desire to video subjects by placing them dead centre

in the frame. We have an almost subconscious desire to do this: for example, if we are filming a person, we tend to place that person's head in the geometric centre of the frame. This makes the resulting footage not only very boring to watch but also a bit odd: the frame seems unbalanced with all the space to the right, left and above the subject going to waste and not contributing anything to the scene. The Rule of Thirds is a rigorous way to use the frame more effectively, more creatively and produce a much more satisfactory result.

Here's how it works. Imagine the frame is divided into three equal bands horizontally and three bands vertically. Subjects (and other scene elements) contribute more powerfully to the composition if they are placed on the imaginary dividing lines of these sections. The composition is even more powerful if an important part of the scene lies at the intersection of two lines. For example, a person standing, placed along one vertical line with their eye line at the point where a horizontal line bisects this will have a very powerful screen presence. This effect should not just be restricted to people – you should think Rule of Thirds for any subject. Even landscape shots can benefit from this approach: placing the horizon along one of the horizontal lines give a far more pleasing result than placing it centrally or closer to the top or bottom.

figure 6.1 Rule of Thirds 1: placing the subject – this power kite flyer – along one dividing line and his head at the intersection with a horizontal, makes for a much more powerful composition that we would get by placing him in the centre of the frame.

figure 6.2 Rule of Thirds 2: even landscapes benefit from the Rule of Thirds. Although not precisely divided, placing the clock on this building at one intersection and the horizon along a horizontal, leads our eye into the scene and focuses our attention.

Perhaps the most potent implementation of the Rule of Thirds is when the principal subject is placed at one intersection of the third lines and another element (in the foreground or background) is placed at the opposite intersection.

Sharpness

There is something of a conundrum in video camera design. The cameras are clearly designed to be hand-held and are expertly sculpted with that in mind. Yet read any book on technique and you'll be strongly advised to bolt the camera to a tripod in order to get the best results. How do we resolve this?

There is no doubt that a camera support of some kind helps deliver steady shots that your audience will later appreciate. The hand friendly design of cameras, coupled with effective image stabilization devices also means that it is possible to get pretty steady shots when you handhold. The type of movie project that you are undertaking should determine decisions about whether you use a support or handhold.

When making a casual video of a family day out, say, handholding will be quite sufficient. In fact, delaying events so that you can set up a tripod will do nothing to gain the support of your friends and family. It could even be argued that handholding adds to the intimacy and informality of such events.

A more formal production will usually demand steadier shots but some documentary type presentations will also benefit from handholding.

Of course there will be caveats in either case. For that family day out, extreme zoom shots – of terrified family members atop a roller coaster – will demand some form of support if you are going to capture every pensive grimace. Conversely those engaged in dramatic productions (the conventional candidate for steady shots) will quote the success of The Blair Witch Project, filmed with virtually no evidence of a tripod.

Shot sizes and types

Creating a well-crafted movie requires something more than propping a camera against a wall and letting events unfold around you. Any movie shot from a single viewpoint is going to look dull to an audience and do nothing for your status as a movie maker!

For a polished production we need to use shots taken from different distances, different angles and different positions. These must not be purely adhoc shots, they must be structured in a way that contributes to the storytelling and the flow – or **continuity** – of the shot. Each shot needs to have a purpose.

Though good movie making is all about creativity, movie makers have learnt over the years that certain shots – and sequences of shots – are more effective than others and so, at the risk of becoming proscribed, use the following shot types based on the distance to, or the angle taken on, the subject. Let's take a closer look.

Distance shots

These comprise those shots where the distance from the subject to the camera is the determining factor.

Establishing shot

Often used in place of a title (and to be recommended over a title wherever it can be successfully used as such) the establishing shot is used to describe the location of the following action to the audience. For example, were we shooting a wedding our establishing shot might be the church (or other venue). There are no hard and fast rules on how close you need be for an establishing shot; for our church example it might be taken from close up or it might be from a distance away, perhaps showing the church in the context of a picturesque village.

The establishing shot can also be not one, but several, shots, if you feel that you need to provide more information to the audience about the location. It's a good idea to shoot several scenes in any case – you can always edit them out later.

Extreme long shot (ELS)

A very wide shot (widest of the conventional shots) where the subjects would occupy one third or less the height of the frame, this type of shot tended not to be used much in cine photography or analogue video because the quality limitations prevented much detail being visible. The advent of digital video and high definition in particular makes this shot more viable, although care should be taken to ensure that the shot is needed and does not merely duplicate the establishing or long shots.

Long shot (LS)

Sometimes used in place of an establishing shot, the long shot or wide shot is used to show your principal subjects in the context of the surroundings. Going back to our wedding example you might follow the establishing shot with a long shot of a pensive groom and best man standing in the doorway of the venue. The formal definition of a long shot says that they should not occupy more than one half to two thirds the height of the frame. They should be large enough to identify them clearly but not to be aware of details such as facial expressions or hand gestures.

Medium shot (MS)

Closing in on the subject, the medium shot begins to increase the prominence of the subject and, to a degree, isolates them from the surroundings. We can now clearly make out the subject, their expression (if the subject is a person). Where the subject is a person they would occupy nearly the full height of the frame.

figure 6.3 establishing shots: iconic landmarks used in establishing shots are a great way of introducing your location to the customer and can often take the place of an otherwise obvious title shot.

Medium close-up (MCU)

If we move in a little closer we might see the subject from the waist up; this would be sufficient to make their face – and expressions – the dominant part of the scene and is usually the maximum distance you might record someone – or a small group – having a conversation.

Close-up (CU)

With just head and shoulders visible, the close-up is a very powerful shot type that is unambiguous about the key element of the scene. Follow the Rule of Thirds for this shot – place the closest eye of the subject at an intersection of the dividing lines and you will have a really powerful image that will engage with any potential viewers.

figure 6.4 close-up shots: the main image here illustrates the extent of a medium close-up, the larger frame a close-up and the inner frame a big close-up. An extreme close-up would show little more than the subject's eyes.

Big close-up (BCU) and extreme close-up (ECP)

Get in even closer so just the face – or even just the eyes are visible and you have very powerful shots where the slightest muscle twitch can convey high drama and emotion. These shots need using with care because not only are they very – and please

pardon the pun – in your face, but they have to be well rehearsed if they are not going to look forced or uncomfortable.

High definition and the distance shots

Shots such as the close-up, big close-up and even the extreme close-up have been used successfully in television drama and documentary for many years. Much of their impact came about because, in the days when a 20-inch television was the norm, a large face on-screen held terrific power, whether that face was of an actor or an interviewee. Now that larger screen sizes are commonplace and high definition video is increasingly mainstream some of the need for these shots is diminishing. From a distance a medium close-up of a subject displayed on a large HDTV will have greater impact than a close-up on a conventional, standard TV.

In fact, big close-ups and extreme close-ups need to be very carefully used with high definition video because the results can be too large and too detailed. In many circumstances you are best advised to shift down a shot size for comparative scenes when shooting in high definition – unless, of course, you want that high drama effect!

Angle-based shots

Changing the angle of a shot from the face-on of the distance-based shots opens a whole new world of movie creativity. Angled shots can add even more drama and also emotions such as superiority, inferiority and loneliness.

High shots

Shooting from a high viewpoint downwards to the subject will diminish their importance and significance. Used with a child, especially, or a pet, it can make him or her look vulnerable and infers inferiority. This effect can be very powerful and it is easy to employ inadvertently. Shooting from our normal eye line at children can mean they immediately take on this humble appearance which may well not be what you wanted at all!

figure 6.5 high shot

Eyeline and point of view (POV) shots

To avoid the inference of inferiority when shooting children (though these shots work with all subjects) consider instead an eyeline shot. For this shot, sometimes called a neutral shot, you bring your camera down to the children's eye level and shoot from there. If you're shooting your pet guinea pigs, go lower still. Eyeline shots immediately make you feel part of the action and produce a greater feeling of equality between the subject and the viewers.

For a point of view shot you switch your position from that which you used to shoot your subject to that of the subject him- or herself. In doing so the audience, instead of having a voyeuristic view of any action, becomes involved in that action even more so than with an eyeline shot and adopts the position (and viewpoint) of the character in the previous shot.

A use of these shots might be with someone on the floor watching television. In the first scene you might have an establishing shot that included the subject, the television and the rest of the room. Next shot, an eyeline from in front, with the subject looking over the camera at the television. In the third shot, a POV, we get the view from the subject's perspective, looking up at the television.

A variation on the POV shot is the over the shoulder shot. The geometry of this shot is self explanatory and it differs from a POV shot in that it keeps the subject in the frame. Sometimes it is a better alternative because it keeps the empathy between the viewer and subject.

Low shot

The counterpoint to the high shot, a low shot conveys, as you might expect, the opposite emotions. Now the camera is in the vulnerable position and the subject becomes dominant. This is ideal for shooting subjects where you want to give the impression of authority; it's ideal for keynote speeches or can be used with irony to show children growing up.

The Dutch tilt

Turn the camera at an angle sideways – rather than up or down – and you're ready to shoot your first Dutch tilt! Why would you want to? It's used to enhance, or perhaps exaggerate, perspective. You might use it to make a tall building appear taller or give a touch of drama to an otherwise bland establishing shot.

figure 6.6a

figure 6.6b the Dutch tilt (and **figure 6.6a**) the diagonal composition of the Dutch tilt can exaggerate perspective or add interest to title or establishing shots.

Zoom shots

The camera's zoom lens is great for composition. You can adjust the zoom so that your shots precisely frame your subjects according to the shot type you wish to shoot. It saves an awful lot of legwork and repositioning. But what else can you use the zoom lens for?

The obvious answer might be to zoom in on your subject while recording. This will send howls of derision among many video photographers – and filmmakers – who will tell you that you never zoom and record at the same time! This, we would say, is being a little messianic: there are situations where to zoom and shoot produces great results. It's how you use the zoom that's important in these situations. Use it either very slowly or very fast.

Used very slowly you could, for instance, zoom in on one face in a crowd. Reverse the zoom action and zoom out from your subject and you've the ideal way to show that subject in relation to the surroundings. That's a good one to use at a sports stadium to show the size of the crowd!

Fast zooms are overt attention grabbers, but to be successful they need to be really fast and you need to keep focus throughout. That can be a problem for many power zooms, that are rather pedestrian in their speed, and with autofocus mechanisms that lose focus at several points along the zoom.

Fortunately, unless you are working with fast moving subjects you can get around these problems. Most video cameras let you 'lock the focus'. That is, you can focus on a subject and then retain that focus position even if you move or adjust the camera position. Lock the focus at the zoomed-in position and then zoom out. Now start recording and operating the zoom. Your subjects will be in sharp focus when you get in close – which is important – and the slightly blurred look at the start of the shot will have gone unnoticed.

To overcome the speed problem you can speed up the scene using your video editing software. The speed of the zoom – and the drama it creates – will overcome any incongruities with the speed of the subjects themselves as the clip is speeded up.

figure 6.7 zoom shot: designed for maximum impact, zoom shots are great for picking up a small detail in a scene.

Homework: watch more TV!

Spend an evening watching TV and see how many of the shot types that we've discussed here are used. You'll be surprised how many sequences – across a broad spectrum of shows – feature shots that can be easily categorized. It's also useful to see how one shot leads on from another. Yes, a few nights in couch-potato mode will actually improve your movie making skills. Honest.

Producing a shooting script

What is the difference between a blockbuster movie and a family wedding? When it comes to scripting, actually very little. Both need a good script and both need to tell a story. Okay, so the scale of each might be quite different, but the same principles and the same rules apply to both.

Why would we want a script for a wedding or, perhaps, a family day out? It's important because, when we come to assemble the day's shooting into a movie we need to be assured that we've been sufficiently thorough to record all the key events and that those events will all flow together seamlessly. When we watch the results we know the events of the day and our mind can smooth over any continuity wrinkles, but for an audience that has not been part of the events any lack of continuity will stick out like that proverbial sore thumb. You'll risk leaving your audience puzzled!

Of course, the shooting script for a day out need not be anything too involved – the movie making should be a record of the day, it should not impinge too much upon it. Before starting out on any movie ask yourself some basic questions:

- What is the aim of this movie? Is it a personal record, something for the family archives or something you want to share with the wider world?
- Who is the intended audience? Is it for friends, family or strangers? Your answer will determine the amount and type of explanations required.
- How much time do I propose to invest in it? Will I be planning to do some heavy editing and compositional work or will the camera footage just be tidied up a little?
- What will be the mood and tone of the movie? Will it be light and frivolous or serious? Will it be dramatic? Each of these could apply to the movie no matter what the genre.

- How detailed a script does it require? Will it need just a few key shots or a detailed work defining every shot and camera angle?

Let's look at these in a little more detail.

What is the aim of this movie?

Much of what we shoot for our own personal benefit is just that – personal. If we plan to produce a movie we need to be more dispassionate and look on the project from a potential audience's point of view. Is the aim to entertain? Or is it a record of an event? Perhaps, as in the case of a travelogue, its key purpose is to enlighten. Whatever the aim it's important to keep focused on that and build the movie around that objective.

Who is the intended audience?

Many of us produce movies because we enjoy it and because it's an intriguing hobby. If others find our movies enjoyable so much the better. The time will come, if it has not come already, when that small part of you that is an emergent movie director takes control and wants to publish your works more widely. Assessing your potential audience is crucial if you want to make widely regarded movies. It's easy to think that you understand an audience.

Consider this scenario. You make a movie about a family visit to a historic house. You might imagine that it will appeal to both your family and friends and the National Trust set. However, that group will be more interested in the details of Capability Brown's landscaping than your family winding down at the adventure playground. Conversely, proud grandparents will want to see more of the little ones playing in the meadows and less of the Palladian detailing.

Now, if you have shot a lot of footage, and worked with an appropriate script you could satisfy both camps, by producing two movies. One includes all your shots of the house and gardens with just a notional inclusion of the family at play, while the other concentrates on the latter. Two for the price of one! You could call one the Director's Cut and the other the Family Addition!

How much time do I propose to invest in it?

When we talk about investing time in a movie we are talking about the time taken in preparation, in shooting and post production – the editing stage. Generally, a more complex movie that takes longer to specify in a script will require more shooting time and more editing time so it's crucial that you match your aspirations with the time available.

Of course, one of the beauties of digital video editing is that you could spend a long time on the first two stages and then produce a simple video, taking very little time indeed. Later, when time permits, you can revisit the project and, with the original shots still available, you can produce a more thorough production.

It's safe to say that an impromptu recording – when we grab the camera in readiness for a day out – will require little in the way of post production. Indeed, it's likely that you won't have sufficient material to build a fully structured movie from the results, especially when you've removed the below-par footage.

What is the mood and tone?

Mood and tone are important qualities in a movie. They define the way you shoot and your approach to editing. In some productions these qualities will be obvious – a wedding will be light and frivolous (or, at least we hope so!). Reportage and documentary movies, though, can range across a wide spectrum.

Does it require a script?

It's wrong to assume that because your movie is not a drama it won't require a script. Even if there is no dialogue, you'll still need a script. A shooting script provides a description of the shots required and is pretty essential if your editing is to be successful. It's very rare that you will shoot a movie in a linear sense, with one scene recorded after the next. Because some scenes will be shot out of sequence it's crucial that you log the progress. Miss a scene and you'll be hard pressed to make good the omission.

However, let good sense prevail. If you need to write a script for an afternoon at the zoo with the family, you're probably taking your hobby a little too seriously! Commendable but unnecessary.

If you think your movie does need a script, where do you start? And how detailed do you need to be? It's hard to give a definitive answer because that answer will vary according to the

nature of the production and the rigour with which you want to produce it. A great way of working is to begin with a brief outline and then begin to detail it where appropriate. You can then build up the detailing as you see fit and to the extent that you need to.

For example, if we were taking a wedding video as friends or family of the bride or groom we might have a simple script outlining the shots we need to take:

1 our friends arriving at the church
2 Lizzy and Jon (bridesmaid and page)
3 shots of the groom
4 bride arriving
5 exchange of vows
6 married couple leaving
7 speeches at the reception.

With that simple list (that you could probably keep in your head) you've got all the key stages that would let you put together a good informal movie.

Now, if you'd been asked to produce a more formal wedding video, not necessarily the official wedding video, you will need to be more detailed and ultimately more methodical. The script then might run:

1 preparations of the bride or groom
 • possibly some words from the parents about their thoughts on the day
 • excited nieces and nephews getting ready
 • arrival of the car
 • departure of the bride
2 establishing shot of the venue [could be shot in advance]
 • some interior shots, too, that could be used in the editing process later
3 early arrivals
 • use different camera positions and get as many of the guests arriving as possible [can cut down later if necessary]
 • groom's parents arriving
 • bride's parents arriving
4 guests arriving
 • some shots outside, some inside
5 congregation taking their seats
 • include some shots of guests chatting
 • long shot of whole congregation

6 groom and best man chatting and waiting
7 entry of the bride
 • mother with tear in eye
 • celebrant preparing for the service
8 full service
 • signing of the register
9 couple leaving.

Notice that as you build up the script more and more scenes become important to the storyline. You'll begin to realize, too, that some of the shots, in shooting terms, overlap. For instance, in our example here we've scheduled shots of the bride departing for the venue but also shots of guests arriving at the venue. Both these, presumably, happen at the same time. Likewise our shots of the bride walking down the aisle (in the case of a church wedding) and the candid shot of the mother crying.

In drawing up a script you can identify situations like this and set about workarounds. For example, you might want a friend with a video camera to get some shots for you or you could stage some parts earlier or later.

figure 6.8 weddings: weddings have a formal structure that needs to be recorded even on the video. Events like the reception speeches need to be recorded in full and only **trimmed** later.

Remember too, that a script, no matter how detailed, should not define the only shots that you take on the day. Think of the script as defining the essential shots; you should also be shooting any other impromptu scenes, many of which can be incorporated into your video, adding to the meaningfulness of an event. A photographer struggling to arrange feuding family members, gusting wind stripping guests of their new hats and mischievous toddlers won't feature in your script, but can add so much to the movie.

The storyboard

As your movie-making prowess continues, you'll find that for some of your productions even a detailed script is not sufficient. You'll have so clear an idea of the needs for your scenes that you'll want to specify not only the shot that needs to be taken but also the type of shot and the camera angle.

This is where film directors turn to the storyboard. Almost in the manner of a strip cartoon, each scene is shown as a simple sketch, sufficient to determine the camera angles, the shot type and to help anyone involved in the movie to visualize the look of consecutive scenes.

This also helps address problems with continuity. When you can see – albeit in sketch form – how one scene follows another, any glaring omission becomes obvious. Consider the case of a scene that features two people talking. The next scene features three people talking. Where did the third person come from? Rationalize this on the storyboard and you'll save having bigger problems later.

Though not limited to it, storyboarding is mostly used for dramatic movies where continuity is crucial. Used with a script it will ensure that you get all the shots you need and will make your life so much easier when it comes to editing. And don't worry if your artistic skills are lacklustre; a storyboard is for your use and to help you; so long as you can interpret your sketches, that's fine!

Summary

In this chapter we've seen that conceiving and constructing a great movie is the result of having a good grounding in basic skills: understanding shot types and visualizing scenes – and skill. Skill develops with experience and we can help that skill develop by being methodical and rigorous in our approach. Working to a script or even a storyboard will take away our need to think about some of the mechanical actions and let us focus on the creative elements.

07

shooting your movie

In this chapter you will learn:
- what to shoot for your movie
- how to think about editing considerations when shooting
- about useful movie techniques and shots.

Now with a script, no matter how general, and perhaps a storyboard, it's time to get out with our video camera and start collecting our footage. We've already discussed some shot types in the previous chapter, but now we need to put these into practice and we need to look at some more techniques that will make our movies – when we come to edit them – even more polished.

One of the things you'll learn as you shoot more and more movies is that there are some useful shots that we can shoot that, while not part of the shooting script, come into their own later when we start editing. And there are more contrived shots that will help the continuity of the movie and definitely need to be planned beforehand.

In the former group come cutaways, inserts and pickups, essentially technical dodges that are designed both to make our editing lives simpler and give greater creative freedom. The second group, including entrances and exits and keeping the line are for the benefit of our audience and are, in a sense, partly compositional dodges. We'll discuss them further in a moment.

Cutaways and insert shots

Cutaways, it could be said, are among the most useful of all shots. They are easy to shoot and provide us with remarkable flexibility when it comes to editing. So what, exactly, is a cutaway? You've probably seen cutaways extensively on television programmes. Documentary and news programmes use them extensively because, in one form, they allow long interviews to be trimmed down to a convenient length.

Often in a long interview there can be some very powerful comments but a lot of trivia. When the studio needs to edit this down to, say, a 30-second slot, simply chopping out the unwanted sections will lead to an interview that appears to be a set of disjointed scenes. There will be a very visible 'jump' at each point where material has been cut. Now, at the join, stick in a cutaway. The interviewer nodding in agreement, a shot of the interviewee's nervous hand movements are good examples. Now rather than an obvious cut, these cutaways make the interview look continuous.

Cutaways need not be limited to interviews; they can be useful in any movie. They are especially useful in wedding videos, for example. If we were to record the whole event there would be

long periods where very little happened. This would make for a rather boring and overlong video. Cutaways, in this case comprising shots of (say) the congregation listening intently can be used to link scenes where material has been trimmed away. Likewise a video of children waiting in a theme park queue could be cut down with cutaways featuring the children staring in anticipation of the ride.

figure 7.1 cutaways: the after-dinner speeches we looked at in the last chapter can sometimes need trimming for the final video production – so make sure you get plenty of cutaways. This pair of teddies is cute, but go for the children if you want the real 'ahhw' factor.

It's good practice to think about cutaways all the time – in fact it soon becomes second nature to shoot some. Remember, unlike our forebears condemned to using film, we're not really consuming any media, so can afford to be generous with our shooting.

Often considered a type of cutaway, insert shots help provide the visual continuity between shots. In a sense they are the converse of the cutaway: where a cutaway compresses time by allowing us to discard sections of our **timeline**, the insert shot suggests that a greater period of time has elapsed compared to that which has actually passed.

In movies there has been an almost clichéd form of insert shot where, to show how much time has passed a cutaway is inserted showing pages blowing off a calendar. Similarly, an insert shot of a clock either counting time fast or superimposing times hours apart suggests time moving on through the day and that whatever the activity preceding the shot, it is still in progress some time after.

figure 7.2 time flies: in a cinematic sense a clock is a good device to use to imply the passage of time – two shots taken at different times, following each other suggests the corresponding time passage.

Pickups

Some movie makers consider the pickup as another specialized form of cutaway, but for our discussions here we can regard it as something distinct. A pickup is, visually, similar to a cutaway but it is used where, rather than material being cut out of a movie, there has been some break in the recording which, after being restarted, would otherwise leave an unacceptable break.

Think of the child's birthday party where, halfway through a great scene the child throws a tantrum. You turn off the camera, sort out the child and carry on shooting. A pickup shot of the cake, say, or children laughing, will bridge the gap between the two disparate scenes.

Entrances and exits

... or ins and outs. When you are working closely on a movie, editing it precisely, it is easy to overlook glaring errors in your continuity. Sadly – for you – your audience are likely to see the error at once.

In the theatre, when a character enters the story they'll enter from one of the stage wings and we'll see, straight away, how they enter the storyline. Now, when we are producing a movie it is very unlikely (and very bad practice) to shoot the equivalent of the whole of a stage so that any people involved make a similarly obvious entrance.

No, in the case of a movie we may be concentrating on two of the actors, with the camera framed tightly on them. Now if a third person is to get involved we must see how they do so if we are to avoid the perception – by the audience – that they have just magically appeared. We could, for example, cutaway to them entering through a door. Or there could be a knock on the door to which a character responds. Or one of the characters could acknowledge the appearance.

There are no rules about how entrances should be made, but it is important that some mechanism is used. Similarly for exits, otherwise even though a character has left the scene your audience will be left with the belief that he or she is still there.

Interestingly, the most common occurrence of bad entrances and exits isn't in drama productions but wedding videos. The video photographer carefully videos the bride arriving at the church and getting out of the car. The meticulous preparations to the dress are made. Now the video photographer dashes into the church to get the crucial aisle scene. In the finished movie we get a sudden jump from static exterior shot to down-the-aisle action. How did the bride get in the church? Interject a short shot taken of the bride about to enter or walking towards the entrance and all is explained.

Keeping the line

You'll see this technique perhaps a dozen times on TV every day – if not more, yet few people outside the TV and movie business will be aware of it. Keeping the line is one of the most important techniques in ensuring perceived – rather than real – continuity. Unfortunately if we were to video some situations as they actually appear, the results can lead to apparent contradictions.

Imagine we begin shooting a conversation between two people by recording them face on, one to the left, one to the right. If we then changed the camera position so that we shot from the right-hand side, and then the left, our two subjects will have appeared to swap sides even though the geometry of the scene remains the same. At best your audience will be confused by apparent juxtapositions.

How can you avoid this? Careful over the shoulder shots is one way or shoot the conversation face on and then use subtle cutaways (perhaps one of the pair nodding in agreement to a comment by the other) to break the monotony of a single shot.

Walking the line

Another instance of keeping the line. Often – again in drama and documentary productions – you'll have two people talking and walking towards the camera. As they continue to walk, the camera will appear to pass between them. Then cut to the same pair continuing the conversation but this time walking away from the camera.

As the rational for the shot is the dialogue, you will probably have been too focused on that dialogue to notice what has happened. The character who, in the first shot, was walking towards the camera, was to the left is, in the second shot still on the left!

Avoiding more potential movie faux pas

Most of us begin our movie making by producing videos that comprise a ragbag collection of shots. And there is nothing wrong with this – a big part of movie making is preserving memories and that's just what these videos do. As we become both more practised and develop a keener eye we begin to notice shortcomings and, in most cases, address them. Our developing skills also mean that we'll be mindful of the issues we've discussed in this chapter.

Here are a couple more techniques – the jump **cut** and cutting on the action – that we can add to the arsenal.

Jump cuts

The jump cut is characterized by a very obvious change between two shots where the camera position does not change. You might have a long shot followed immediately by a medium shot (or even a medium close up) of the same scene. The effect is similar to a very fast zoom and is a great way of concentrating your audience's attention on a subject.

This is also an effect that can be achieved inadvertently. Imagine you have been filming a child playing with some toys, discretely from a distance. You decide to chance catching the child's attention and move in closer to get a close-up. Now, when you replay these scenes the child will appear to leap forward. Dramatic, but not in the intended sense!

Where you do plan to use a jump cut you will generally have to stage it. It is important that between the two shots there is no apparent motion in the subject. After shooting the first shot you'll have to shout 'cut!' (and haven't you just been itching for the opportunity?) at which point everyone involved freezes. Reposition the camera (or zoom in or out), start the camera and shout 'action'. Now everyone carries on.

figure 7.3 a and b jump cuts: the idea may seem logical – to zoom in between shots for more detail – but the effect on screen is of the subject 'jumping' forward.

figure 7.4 a, b and c avoiding jump cuts: dropping in a cutaway shot between two shots that might otherwise produce a jump cut overcomes the problem.

Cutting on the action

Here's another group of shots that need to be rehearsed and staged for maximum effect. Imagine you are making a movie about your local football club and are recreating their victory in a penalty shootout. You could place the camera in the midfield and shoot the whole event as one long scene. You might want to add in a few cutaways (perhaps close-ups of the face of the shooter or goalkeeper, or a pensive crowd) shoot the whole event from a single camera angle.

A better way – and certainly a way that would better engage with the viewers – would be to get in on the action. How about this?

Shot 1: long shot of the goal area with the shooter placing the ball

Shot 2: from the goalmouth, medium shot of the shooter addressing the ball

Shot 3: cutaway of the goalkeeper's expectant expression

Shot 4: medium shot from behind the shooter as he moves forward and kicks the ball

Shot 5: cut to the goalkeeper catching the ball.

We call this process – which involves several takes – cutting on the action.

Summary

Creating a movie is easy. Point-and-shoot wins again! Creating a great movie is a little harder but with a little knowledge of the methods used by the pros we can lift our movies from the ordinary to something more special. We've seen how a range of simple techniques from cutaways to jump shots can provide us, when it comes to the editing stage, with some key shots that not only will help deliver a better movie but give flexibility in the ways we edit.

08

light and lighting

In this chapter you will learn:
- about the key lighting types
- how digital video cameras interpret and respond to different lighting types
- how we can exploit and enhance lighting.

We tend to take light and lighting for granted. So adept are digital video cameras at working with available light – even when there isn't that much of it around – that we tend to pay scant regard to it. In fact there is a big difference between a lit movie and a well-lit movie. With just a little knowledge of the way light works and the way your camera works with that light you really can transform the look of many a scene.

Light can also play its part in helping interpret an audience's perception of a movie – or at least scenes in the movie – affecting the mood and, to use an arty but effective term, the 'look'.

In professional movie making there will be an army of lighting engineers who can achieve virtual miracles with lighting, transforming almost any scene in a way the director explicitly demands.

Light sources

Natural or artificial: is a very broad and sweeping way to divide all light sources. However, each of these categories contains a remarkable diverse selection of sources. Of course, for the vast majority of our movies we will be constrained to use available light sources – whether artificial or natural – and will need to make the best of what's available. Difficulties only arise when you get a mix of the two.

In general, and this is something of a sweeping generalization, artificial light tends to be warmer than natural. View a conventional light bulb alongside daylight and you may see the cooler look of the daylight compared to the light bulb. Shoot the same sources on your video camera and the differences will be very much more marked. That's the first problem we encounter with our cameras. It is one that's been recognized. Using the white balance control on the camera you can set the camera to compensate for any colour cast.

The white balance control is great when we want to remove a colour cast when shooting indoors, for example. But it can have limitations. For example, it can only deal with one colour cast at a time: set the balance to compensate for indoor lighting when shooting indoors and any exterior views – such as those through the windows of the house – will, thanks to the compensation, look even colder and more blue. Conversely, set

the white balance to compensate for that colder daylight and any artificial lighting will be a more pronounced amber.

White balance presets

A typical white balance control would feature several presets including:

- auto: automatic white balance based on the light sources present
- sunlight: balanced for 'mean sunlight', the type of sunlight you might get around midday. If you apply this setting and keep it throughout the day you will be able to successfully record the warm lighting you get around sunrise and sunset
- broken cloud: balanced for skies that feature a mix of clear blue and bright white clouds
- overcast: balanced for evenly overcast skies
- tungsten: balances (that is, removes) the amber cast due to standard household GLS tungsten bulbs
- fluorescent: (often two or three settings) compensates for the colour casts produced by fluorescent tubes. There are several different types of fluorescent tubes and the different settings can help cancel the magenta, green or warm casts produced by the principal types. The warm setting is also suitable for the low wattage energy saving GLS replacement bulbs, which are increasingly common.

Auto white balance? You might think that activating this setting would be ideal, but not necessarily. Set the camera to this and it'll assess the best (that is, most neutral) setting continuously. That's fine so long as the light sources are pretty constant but as the mix of lighting sources – as seen in the viewfinder – varies, so will the white balance, changing the colour cast across the entire frame.

However, where the lighting types don't vary wildly using auto white balance as your default setting is a good idea because it will provide you with an acceptable 'average'. Bear in mind also that when you come to edit your movie the software generally includes controls for varying the colour cast which can be used to apply remedial corrections.

Light through the day

Light varies dramatically through the day, in intensity, colour and quality. Given anything other than an overcast sky, daylight is at its most harsh and unforgiving for a couple of hours at midday. In summer, particularly, you'll get harsh shadows and very contrasty results. At the extremes of the day the light levels are much lower and the light becomes much softer and warmer. Look at Plates 1 and 2 for example.

Our camera's exposure system is adept at handling the differences in light levels – over a surprisingly wide range – and the white balance controls will, to a greater degree, compensate for the changes in colouration. Because our cameras – and our eyes – are so good at compensating, it can be hard to be objective about light sources and their colour. So, to inject a little objectivity, we can use a scale called 'colour temperature' to define the different light sources that we use.

The basis of colour temperature is based on black body radiators, a somewhat theoretical body that radiates light based on its temperature. Physicists use this scale extensively as do astrophysicists who use it as a scale for the light radiated by stars, but for our purposes it's more of a relative scale.

Professional photographers – both still and video – will use colour temperature meters to calculate the colour temperature of a scene. Then they will use filters (often very subtle in coloration) to adjust the colour temperature to ensure consistency from scene to scene. We are unlikely to need such precision but it's useful to be aware of the scale and to appreciate the difference in colour between light sources that our eyes tend not to discriminate between.

Most useful for our purposes is the objectively perceived colour. This is the colour of the light if you were to see it compared with pure white light. People using video cameras for the first time can often be taken aback by the amount of variation in light colour in their movies so it is useful to be mindful of the variation but, be assured, you will quickly learn those situations where overt casts appear and where you need to intervene to correct or enhance.

Colour temperature		
Source type	Colour temp (K)	Objectively perceived colour
Blue sky, no clouds, no haze, overhead	18,000	Blue
Blue sky, moderate haze	10,000	Light blue
Shade and shadow areas under blue sky	8,000	Blue/white
Even, light overcast sky	7,000	White/blue
Even, moderate overcast sky	6,500	White/blue
'Average daylight'	6,400	White
Mean noonday light	5,400	White
Early morning/evening sun	4,500	White/yellow
Post dawn/pre sunset	3,700	Yellow/white
'Photoflood' tungsten photographic bulb	3,400	Yellow
Halogen video lamp	3,300	Amber
100w GLS domestic light bulb	2,750	Orange
Sunrise/sunset	2,000	Orange/red
Candlelight	1,500	Red

Illumination levels

Almost as surprising as the coloration of light is the variation in light levels between bright and dark subjects. Illumination levels are measured in a unit called the 'lux'. If you take a look at your camera's instruction manual you'll see the minimum lux level that it is designed to shoot at. This can be an ambiguous figure, as many cameras will shoot successfully at levels lower than this, whereas some will produce noisy, grainy images at levels above the minimum.

Your camera will, though, be able to shoot good images across a remarkably wide range of illumination levels. Take a look at the table showing the lux levels for different scene types and you'll see how wide that range – from the brightest of snowfields though to a candlelit interior – can be.

Scene type	Lux
Pristine snowfield or bright sunlit beach	100,000
Sunlit landscape in summer	50,000
Same sunlit scene in winter	15,000
Even, overcast sky	5,000
Sunlit landscape at sunset/sunrise	500–1,000
Brightly-lit domestic interior	250
City streets at night	50
Dusk or candlelit scene	5–10

Low light levels

Traditional advice tells us to provide as much light as possible when shooting. And it's good advice. The more light we have the better the colour and contrast in our scenes and also the better our camera performs. The electronics in the camera work best at moderate to high levels. (See Plates 3, 4 and 5.)

We'll have situations where we need to shoot at low light levels and where we need to maintain the mood of those low light conditions. It may be a sunset, like in Plate 4, or a candlelit scene like in Plate 6. Your camera should be able to handle these pretty well. Sometimes over zealous auto exposure controls will tend to over-brighten the scene, but this is not something to be unduly worried about – we can correct this later when we come to edit the movie.

A drawback with shooting at low light levels – and all cameras are affected to different degrees by this – is the increasing noise in the recorded images. Noise, we should add at this point, is not audio noise but rather a term to describe electronic fluctuations visible on the video signal. Think of it rather like the 'snow' you see sometimes on a poorly tuned TV picture or as a graininess overlays the picture.

The extent of this problem increases as the light levels fall. Why? It's down to the electronics in your camera. All electronic circuits produce some random electronic noise. In most situations the level of this noise is so small compared with the signal that the circuits are handling that they are, to all intents and purposes, invisible. That noise is present in your camcorder's electronic circuits and may amount to the equivalent of a few lux. Not much when you are shooting scenes flooding the circuits with many thousands of lux but more significant when shooting at, say, 100 lux.

How can you avoid it? In a word, you can't, but you can minimize it by increasing the light levels slightly (a small change can make a big difference). Or you can use it creatively. The graininess imparted can give a romantic or mysterious feel to your low light and candlelit shots.

Improving lighting

There are several steps you can take to improve the lighting in your shoot depending on the equipment you have and the amount of latitude you have in arranging a scene.

1 *Add more light* If you are shooting indoors you'll find that your camera will successfully shoot at low light levels but that the results delivered will be less than successful. Unless you need (for mood or otherwise) the light levels to be low (and in which case the grainy, muddy look may be acceptable), turn on as many interior lights as possible. Higher light levels should not compromise your shots and will deliver results where colours are brighter and there is less 'noise' in the picture.

2 *Add auxiliary lighting* Where you have the ability (and again we are talking about indoors, principally), add some extra lighting. You don't need to resort to bringing your lighting rig with you here – a powerful domestic uplighter (with an output of 300W, or equivalent) is sufficient to flood an average room with enough light. Uplighters also have the benefit of delivering shadowless light (as the light is reflected from the ceiling) which avoids problems associated with direct room lighting (where subjects may move in and out of shadow as they move around the room).

3 *Add a light to your camera* This is not a favourite of mine nor of many video photographers because the lighting it provides is harsh and directional. But there may well be occasions

when it's your only option. See Plates 7, 8 and 9 for an example. Camera-mounted lights today often use powerful LCD bulbs to deliver comparatively bright lighting without consuming too much power. That power is derived from the camera itself, though many models have their own rechargeable battery packs to give you the freedom to wander anywhere with the camera.

figure 8.1 LED lighting: auxiliary LED camera lights are bright and energy efficient, but because they tend to produce hotspots, they should only be used where this would not constitute a problem.

4 *Rearrange your scene* Contre jour, or 'against the sun' is a problem in many areas of photography. When your subjects are between you and the key light source, normally the sun, they become silhouetted as the camera's metering system tries to balance the light between the subject and the much brighter background. Overriding the exposure to compensate (some cameras have a button marked 'backlight compensation') gives a good, or better, exposure for the subjects but will wash out the background entirely.

Unless it is essential that you shoot from this angle, move your camera position or your subjects so that the sun is making an oblique angle with those subjects. Even at comparatively modest angles you'll find that your background becomes a lot less bright and the illumination of the sides of your subjects' faces will deliver a result that is also more three-dimensional than when backlit. If moving your subjects is not viable (because, for example, you need to shoot them against the specific backlit background) then take a look at the following suggestions.

5 *Wait for the sun* Where your contre jour lighting is down to the sun, you could wait a short while for the sun to move

from its contentious location. Even an hour's wait will result in the sun moving some degrees to the West (if you are shooting in the Northern hemisphere), sufficient to move it from the line of site and give the oblique lighting that we mentioned above.

6 *Use reflectors* Getting even lighting is one of the biggest problems. Whether it is the unevenly lit room of contre jour situations or not, the high contrast between bright and dark areas is a problem for your video camera. Adding your own lighting is one solution, as we've already described, but to fill in shadows due to the sun even the mightiest of camera-borne lights will struggle. Instead, you'll get much better results using a reflector. Reflectors – panels of reflective material – will (at the risk of stating the obvious) reflect the incident light back into the scene. So if you have a bright source of light, a proportional amount of light will be reflected back to fill those shadows.

You can get portable reflectors that fold away to pocketable sizes – or at least sufficiently small to fit in a gadget bag – or you can improvise on location by using rolls of aluminium foil. In the case of the latter make sure that you use the matt side rather than the shiny, to provide even reflections.

figure 8.2 reflectors: collapsible reflectors such as these from Lastolite are a convenient way of reflecting light into shadows and, if the reflector is coloured, warming up that light.

7 *Add darkness* Take away light? Sometimes yes! Lighting crews on movies have a whole host of tools, such as reflectors, available to modify lighting but one of the most used are black reflectors. Not reflectors as such, these devices block reflections and are useful where you want to accentuate shadows.

As ever, don't let your shooting be constrained by the implied rules we've included above. Contre jour, for example, can be used to very powerful effect when shooting early morning and late evening scenes when backlighting due to the rising or setting sun can add much to the movie.

Summary

Light is crucial to your movies. Not only the presence of light (which is a rather obvious comment) but the quality of that light. It's important to recognize how the amount of light varies with weather conditions, and also the type of light. Your knowledge of light quality will develop with experience but remember that your camera can be rather unforgiving and shows the world in its true light!

09

recording sound

In this chapter you will learn:
- about the mechanics of sound recording
- about the tools required for great sound recording
- about different microphone types
- some rules for getting great sound on location.

It's sad but true. The sound track on many a home movie is the poor relation of the video. Because video is, obviously, a visual medium and many of us have graduated to it from still photography, we tend to pay scant regard to the sound that we record alongside. We describe that as 'sad' because the sound is equally important and a poor soundtrack will seriously detract from the quality of your productions.

Now for the good news. Camcorders are capable of recording pretty good sound along with your video. Some accessory microphones can make things even better. Throw in a little skill and judgement and a great soundtrack can be yours!

Evolution of sound recording

Television today – and indeed through technologies such as NICAM for some years – has offered very high quality sound reproduction. We've become accustomed to this high quality to the point where we can discriminate against a recording that is below par in any way. It's interesting to look back at the cine world. Most cine films were recorded without any sound at all. The commentary would be provided by the photographer or, more likely, contributed to by all the assembled friends and family.

When sound came to cine photography it did so in the form – in the popular Super 8 format at least – of a very fine magnetic track along the edge of the film. In fact, there were two strips of magnetic material – one adjacent to the cine frames and the other adjacent to the sprockets to keep the film balanced in the projector. It sounds like a solution that was doomed to failure, but in fact it worked very well in its day and the balance track became even more useful as stereo sound was demanded!

Of course, the sound offered was considered good largely because it was novel. Prior to this only professional cine films and movies boasted sound. Consumer video cameras offered sound from day one and, surprisingly, used a system rather similar, with edge-recorded sound. As contemporary televisions were, on the whole, incapable of reproducing high quality sound this was no problem although now, when we come to compare these recordings with those from digital video cameras, the difference is not only clear, but also substantial.

The twin virtues of sound recording: level and quality

Before we can get to the stage of editing or refining our soundtrack, we need to record it! And record it well. For this, we must be mindful of two things. First, the level of the sound.

Sounds, as we're sometimes painfully aware, can be very loud, yet at other times they can be almost inaudibly soft. Yet we need to be able to record all sound levels accurately, both in terms of their tone and level. This can sometimes prove problematic because the microphones – and the electronics that process the sound – in most cameras don't know how loud sounds are. They do their best to record any sound at an optimum level. So you'll find quiet sounds are boosted to increase the sound level while loud sounds are muffled – as it were – to make them quieter. In general this is actually really useful. It means that you don't have to worry about the level of the sound you are recording. You can be assured that the camera will always record the best possible sound level and avoid the potential for distortion.

Problems arise, however, when we come to mixed sounds. We can draw a parallel here with our video signals. Controls such as auto white balance and auto exposure are always monitoring the video signals and adjusting to give the best results. As we've already described, when the lighting levels vary – and you want to maintain that variety – you can sometimes find your results compromised. Auto controls work well perhaps 80 per cent of the time, but for that 20 per cent you can run into difficulties.

Some cameras – usually the semi-professional models – do give you more control over the sound levels (as they do with exposure, for example) but in the absence of any control (and to be honest sound controls can, for our purposes, often be more trouble than they are worth) we need to make sure that we record the best quality sound of which our camera is capable. We can attend to variations in the level of that sound later, when we come to edit our movies.

Sound levels

Again like light, sound levels are absolute but the sound we perceive (and might record) varies in its intensity, proportional to our distance from the sound source. A light bulb will be regarded by your camera as a bright light source when shooting

close to it, but as an almost insignificant one when shooting from a distance away.

We have to be mindful of this distance factor when considering sound. In an attempt to be objective sound engineers use the decibel scale – a logarithmic scale where an increase in decibels of three is equivalent to a doubling of the sound pressure or, as we generally describe it, the noise!

The table of sound types illustrates how different sounds that we are likely to hear (almost) daily compare.

Sound type	Sound level (dBs)	Perception of sound
Siren or alarm close up	140	threshold of pain
Aircraft at take-off	130	
Thunder within 4 km	110	'deafening'
Pneumatic drill	100	
Interior of tube train	95	'very loud'
Motorway traffic	85	
Family car interior at 70 mph	70	'loud'
Conversation	60	
Office or shop interior	50	'averagely loud'
Suburban streets	40	
Countryside	30	'quiet'
Whispers	20	
Sound-proofed room	10	'very quiet' 'silent'
	0–5	threshold of hearing

It's worth noting, too, that the extremes – threshold of pain and threshold of hearing – will vary according to the frequency. Our ears, for example, are likely to be deaf to very low frequency sound (deep booming ones) up to 70 or more dBs. This lack of sensitivity also varies according to age with, again in general, older people's hearing becoming less acute and less sensitive to higher frequencies.

So how does this relate to our movie making? Fortunately we don't need to memorize sound levels or comparative lessons.

Nor do we need to know anything about the details of decibels. However, it's important that we are aware of how noisy things in our environment can be. It's extremely useful, for example, to be aware that if you are shooting a street scene involving conversation, the noise from the nearby motorway is likely to be at least as loud!

The quality of sound

Sound quality, as we've already suggested, can be subjective and can be influenced by our expectations. For those of us brought up with – in recent years at least – high-quality, easily accessible sound sources, ranging from CD through digital radio to digital surround sound on DVDs – those expectations have been raised high. And, as we've also noted, those expectations are matched by the capabilities of the digital video camera. The camera is able to record high-quality sound, but that ability is dependent on high-quality sound being made available through the microphone.

Pros and cons of the inbuilt microphone

All digital video cameras are provided with a microphone built in. In general this is of excellent quality and, in all but a handful of cases, offers stereo recording. Stereo sound will be expected by our prospective movie audiences because it gives that depth of sound and also lets us locate sound with objects on the screen. Most cameras also offer the option of connecting an external microphone. If you've ever seen behind the scenes of a television or movie production you'll have noticed that it's pretty rare to see a camera use a built-in microphone; instead a host of external microphones are positioned to get the best from the scenes. So, given that the professional movie maker is our exemplar, does that mean our humble inbuilt microphone is, in practical terms, frivolous?

Not at all. We'll see in a moment that we can also use auxiliary microphones – like the pros – to record high-quality sound, but what of our inbuilt one?

It's convenient. Your camera is an incredible one-box solution to movie making, and that includes sound recording. Small though the microphone may be, it can add a pretty good soundtrack to your video – automatically. Many movie makers use nothing

else. But, and of course there is a but, it does have some shortcomings.

First, the inbuilt microphone is, in acoustic terms, omni directional. That is, it will record sound from all directions. Unfortunately, because your camera is shooting footage of that part of the world in the viewfinder, you may not necessarily want the intrusion of sounds emanating from your side or even behind the camera.

Not only does the microphone record sounds from all around the camera, it also does so from the camera itself. Unless you are blessed with a solid-state memory camera which has no moving parts to its recording system, the winding of the videotape or the spinning DVD (or hard disc) contribute noise. Quiet this noise may be but it will still be intrusive and even the less astute viewers will notice it on occasions. You can add to this noise – and this is true for all models – the noise due to other control operations. The obvious one here is the zoom lens. If you operate the zoom during the shot the noise of the tiny motors that propel the components of the lens to their appropriate positions will also add to the system noise recorded.

With an inbuilt microphone there is no way to avoid this although, as you'll appreciate, it only becomes obvious in quieter spells of your recording.

If these issues were not enough, your inbuilt microphone – like all microphones – can fall victim to wind noise. Wind blowing across the microphone will produce a characteristic whine. Professionals will use a windsock or baffle over their microphones. These fluffy covers break the airflow over the microphone itself and reduce wind noise to a negligible amount. You can achieve a similar result by fixing a piece of faux fur fabric over the microphone but care is needed to ensure that you don't obstruct the microphone in any way when fixing this in place, or allow the fur – or fixings – to creep into your shots.

Finally, the inbuilt microphone, like so many other aspects of your camera, is designed for 'average' conditions. And for sound recording this means averagely loud subjects at what the manufacturers consider an average distance from the camera. In practice this means that if you have subjects speaking they should be around five metres from the camera (and certainly no more than ten metres) and noisier subjects, proportionately further away. Remember that when a subject is twice the distance from you, the sound – whether speech, an engine or

whatever – will be one quarter as loud. Your camera's sound system can adjust for distance up to a point, but will eventually reach its limit.

Adding an external microphone

There are many reasons why you might want to add an external microphone, of which several are responses to the shortcomings we've noted above. In particular, you might want to consider an external microphone to:

- provide directional (rather than omni directional) sound recording
- overcome the noises generated within the camera
- record sounds that are beyond the range or too soft for the inbuilt microphone
- record even better sound than that of which the camera's own microphone is capable.

Microphone masterclass

Perhaps more so than cameras, microphones exist in a world where the jargon of acoustics is likely to baffle any one of us out to source the best device for adding to our camera. Before we take a look at the different options with regard to microphones and microphone placement, let's take a look at the key microphone types and get to understand a little of that jargon.

Cardioid

Microphone sensitivity is generally expressed by drawing a graph of the sensitivity at different angles from the tip of the microphone (or, in layman's terms, the bit at the front that the sound enters), called a polar diagram. The cardioid, often sold as a standard external microphone, has a broad range of sensitivity covering the whole area in front of the microphone across an arc of 180 to 200 degrees. The polar diagram shown here (Figure 9.1) illustrates this. The black, arrowed lines illustrate the sensitivity of the microphone in different directions – the longer the line the more sensitive it is. You can see that in the case of a cardioid microphone the sensitivity remains constant through quite a wide range of angles. That's the first and last time that we'll examine a polar diagram, but it is useful for visualizing sound sensitivity.

Plates 1 and 2 Lighting at sunset becomes soft with very gentle gradation. Unless, as in the second shot here, you are deliberately shooting a silhouette, shadows and contrast are less marked than at other times of the day.

Plate 3 Shots like this benefit from great lighting that, in the middle of the day, doesn't require any overt compensation or correction either in the camera or when editing.

Plate 4 Modern digital video cameras are adept at capturing great images across a wide range of lighting conditions. You'll get great results whether you are shooting at 100,000 lux or 10 lux!

Plate 5 Snow reflects a lot of light and can result in over-exposure unless compensation is made; the colour balance can veer towards colder colours unless the white balance is adjusted accordingly.

Plate 6 Shooting at low light levels such as this candlelit scene can give great results but the low light levels can make the image more 'grainy' due to electronic noise.

Plates 7, 8 and 9 Using a camera mounted light can produce a 'hotspot' as in the first image here. Newer, LED based lights can sometimes make this hotspot even more pronounced. Ideally, increase the room lighting to deliver sufficient illumination.

Plate 10 Fog effect.

Plate 11 Rain effect.

Plate 12 Tracking error: playing a video tape – particularly an old one – using a VCR other than that used to record it can result in poor performance, some of which can be cured by adjusting the tracking control.

Plate 13 Wavy edge: an artefact of analogue tapes, the wavy edge effect can affect moderately to well worn tapes and also less worn tapes played though an older VCR. You can remove it by cropping the frame but take care not to crop too much as the analogue frame is already of lower resolution than that of a digital video.

Plate 14 Templates make it easy to produce a professional DVD. All elements can be customized.

Plate 15 You can change the template to one that might be more in keeping with the nature of your production.

Plate 16 Selecting map view gives you an overview of the links between menus and scenes. The one shown here is for DVD Studio Pro.

figure 9.1 polar diagram for a cardioid microphone.

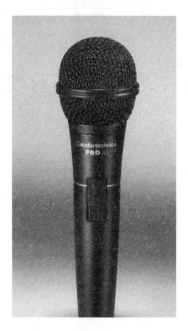

figure 9.2 cardioid microphone: suitable for recording all sounds in a forward direction.

Supercardioid

If you restrict the sensitivity to an area broadly in front of the microphone of around 120 degrees you need a microphone called a supercardioid. Because the sensitivity is biased towards the front it will be better at picking up sounds from the subjects and the area in their vicinity.

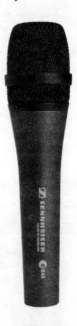

figure 9.3 supercardioid: looking similar to a cardioid, but with a more restricted forward sensitivity.

Hypercardioid

Restrict the forward sensitivity even further (to around 90 degrees) and you can really focus your recording on subjects ahead of the camera. That's the rationale for the hypercardioid microphone. Like the supercardioid these microphones are not deaf to sounds from either side or even behind, but because the forward sensitivity is so much greater you will be able to record a mix of sounds – from the subject(s) and the environment – which gives a better focus, and one that is skewed towards your subject.

Microphones: tools of the trade

When we want to go that step further than using the inbuilt microphone we've several options:

- an on-camera auxiliary microphone
- boom-mounted microphone
- detached, specialized microphones
- wireless microphones.

The simplest improvement it to use an *auxiliary microphone*. Easily attached to the camera's accessory shoe mount (and connected to the recording electronics using special contacts in the shoe or a simple cable), these take the microphone away from the body of the camera. This allows us to substantially reduce the risk of recording sound from the camera itself. These microphones also tend to be cardioid in design, and so allow a degree of focusing in the sound recording compared to the inbuilt microphone.

Zoom microphones are a popular choice for an auxiliary microphone. These can be switched between two or more settings to record a wide angle of sound or a narrower one. It's equivalent to switching between a cardioid sensitivity and super- or even hypercardioid. Most models have a manual switch but some are electronically matched to the host camera and will zoom their sound sensitivity in parallel with the zooming of the lens.

figure 9.4 zoom microphone: still compact, zoom microphones allow you to zoom the sound sensitivity to record sound from progressively smaller regions ahead of the microphone.

Auxiliary microphones are generally compact and, price wise, relatively inexpensive.

Boom-mounted microphones ape those of the professional. They comprise (normally) a cardioid design that is mounted on a long pole (the boom) that allows it to be positioned closer to the source of any sound. This is the microphone arrangement most commonly used in television and movies where the microphone is placed over the heads of (and just out of sight of the camera) the actors.

For most of the movies that we are likely to shoot, a boom microphone, though effective, is likely to have serious drawbacks. Mounted on a camera (or alongside the camera on the latter's tripod) it becomes cumbersome to use. Used separately, it requires us to have a second person with us – a soundman – to hold it securely in place.

If you are involved in a major production then this may be justifiable, but for your holiday or wedding movie it might be too intrusive. A zoom microphone will probably be a much better bet.

Where you do need to record very good sound from a specific area of the shot you can resort to *detached microphones*. If you've been commissioned to produce a wedding video there are some elements of the service that will need great sound. The vows, for example. Participants and celebrants will probably baulk at the idea of a boom mic and a zoom microphone risks recording muffled sounds from anyone with their back to the camera.

In these situations it's best to use microphones that you can place close to where the key speeches are being made. Photo stores stock a variety of microphones that will fit this bill, offering connection cables of varying lengths. The type of microphone needed for an application will depend on that application and how discrete you wish to be. Microphone technology – like that of other electronics – has evolved to the point where a small device can record high-quality sound. Lapel microphones are a good choice for recording speech and can easily be concealed from view. These feature microphones that are optimized to recording speech up to half a metre away, so they are not ideal for general-purpose sound recording. Similar sized microphones – but designed to record a wider range of sound over a greater distance – are also available.

As an aside here, if you are shooting a wedding, or perhaps a speaker, there may already be microphones in place, especially if the acoustics (or size) of the venue make it hard for visitors to hear clearly unaided. You can sometimes link into these microphone systems and record the sound directly from them. This is not something that you can necessarily turn up and do on the day – think ahead and, if you think this might be an option, visit the venue well ahead of any event and investigate the possibilities.

A variation on the detached microphone that's often more practical – if more expensive at the outset – is the *wireless microphone*. This saves the connection required to the camera and it is better (and safer) if the camera or subject being recorded is moving: no risk of tripping accidents! Of course, you also have the benefit of a greater range than that to which wired microphones are limited.

Recording sound

We've been through the theory and studied the hardware options; now we can go out and shoot great sound to accompany our video. Recording good sound shouldn't be too onerous. The important elements are

- to ensure that your subjects are in range of your microphone
- that their voices (if your subjects are people) are sufficiently distinct from other sounds
- you've been mindful of audio continuity.

With regard to ensuring that your microphone has picked up the right sounds and has done so at the correct level, how do you ensure this? The best way is to plug a pair of headphones into the monitor socket on your camera and listen to the sound being recorded. This is not something you necessarily have to do every time that you raise a camera to your eye, but it's a good ploy to use until you get the measure of your camera's recording capabilities. You don't need anything too sophisticated – although 'closed' headphones, which eliminate a substantial part of the environmental sound, are best. A cheap pair that can be slung into your camera kitbag will be sufficient.

What about audio continuity? In professional productions, when the angle of the camera changes – for example when cutting between two actors, or when looking at different views

of the same location – the background, or ambient, sound doesn't change. If those two actors were in a bar, for example, as the shots changed back and forth between the actors the background music would continue uninterrupted. This is despite us – as movie makers, realising that the scene would have been shot as a series of separate shots. Truth is, this background sound was probably added later (and we shall explore how we can do likewise later on, when it comes to our editing processes) but it is so easy for us to fall foul of similar situations when recording our video shots.

Shooting two or three shots from the same location, but with the camera pointing in different directions, will almost certainly result in background noise that is different from shot to shot. Subtle the changes may be, but they will be sufficient for the audience of your finished movie to notice.

So how do we avoid this? We need to think ahead. Record some extra footage with the camera in a fixed position. Later, when we come to edit the movie we can extract the soundtrack of this extra footage and lay it over the top of the existing footage. With some careful manipulation of each we can overcome any irregularities or continuity errors. Pro movie makers describe this as recording ambient sound or, recording a wild track.

Summary: ten tips for getting the best sound on your video

1 Use headphones to monitor your audio recordings where practical to do so.
2 Invest in an auxiliary microphone.
3 Pay attention to any distracting sounds in the environment of your camera.
4 For important assignments check out locations and venues in advance with regard to sound.
5 Use a wind sock or similar on your microphone to ensure wind noise is kept to a minimum.
6 Don't operate the camera's zoom lens unnecessarily when shooting, thus minimizing camera noise if using the inbuilt microphone.
7 On those big assignments a sound man (or woman) with responsibility for sound and microphones can take a lot of the pressure off the cameraman.

8 On location, record ambient sounds to give you more flexibility when editing your movie.

9 Avoid recording narrations on location – shoot footage to which the narrative can be added later.

10 'Are you filming now?' Brief friends and family when shooting to avoid having them talk to you during a shoot!

10

importing video to your computer

In this chapter you will learn:
- how to get your video recordings on to your computer
- how to get the best results from your computer
- how to fast-track your video to disc.

In this chapter we'll take our first steps towards editing our movie. We'll presume that, by this stage, all our footage – good and bad – has been recorded and is waiting expectantly in the camera. So how do we get it from there to our computer? And, once there, how do we make sure that our software is well placed to work on it?

Getting the footage – or to be more precise, getting the digital files that contain our footage – across to the computer is a relatively simple task. The details will depend on the type of camera we've been using (one that uses miniDV tape or recordable DVD, for example), because each type has a slightly different method. It is also a process that, first time around, can be prone to glitches, so we'll also spend some time exploring potential problem areas.

Downloading from a DV camera

As the majority of camera owners use a DV camera – or certainly the majority of us who are likely to want to edit our movies – let's take a look at this first.

Connecting your computer and camera

The first step is to connect your computer and camera. To do this you'll need to use the cable supplied with your camera to connect the camera's digital output to the FireWire socket on your computer. This cable typically has a small, four-pin connector at one end (the end that plugs into the camera) and a larger, six-pin plug at the other.

Don't worry if you've misplaced your cable – you can usually pick up another at a photo or computer store. You may also need to pay a visit to that store if your computer doesn't have one of the large FireWire sockets. Although these large sockets (which can provide power to external devices as well as data communications) are standard on Macintosh computers, many Windows machines – especially laptops – tend to have a four-pin socket.

Often the FireWire connector on your camera (that will be marked as iLink on Sony cameras) can be well concealed. Because it is not needed on a day-to-day basis, and to protect the tiny socket from the potentially damaging ingress of dirt or grit, you'll have to search behind the flaps and trap doors

figure 10.1 FireWire connections: six-pin and four-pin.

figure 10.2 FireWire socket: on this Sony camera the FireWire socket is hidden behind a flap; alongside is the larger **HDMI** connector. This is for downloading high definition video from this HDV camera.

around the camera. It may well be found along with other connectors: some cameras will also have output connectors designed to allow the camera to connect directly to a television.

When the connection has been made, turn on the camera and select VTR (or 'Play') mode. That's the mode you'd typically use to review shot footage on the camera, rather than the mode used when shooting new footage.

Starting the software

To start downloading your footage you'll next have to start your video editing software. Start the software and, if you are creating your first movie, create a new project. The project will include your new footage and, later, any additional resources that we choose to add such as music, images and special effects.

You will also need to choose a format for your new project. The options you'll have (which may vary according to the software) and their use include:

- DV **PAL**: the standard format for a DV-based project in countries where PAL is the television standard. This includes the UK, South Africa, Australasia and much of Europe
- DV **NTSC**: the standard for a DV-based project in North America, Japan and some other countries
- DV PAL WIDESCREEN, DV NTSC WIDESCREEN: the same as above but using a widescreen format
- MPEG-4: importing video recorded on cameras (such as hard disc drive and memory card cameras) that use MPEG-4 rather than DV as the recording standard
- HDV **720p**: a project using source material from an HDV high definition camera recording in 720p format

- HDV **1080i**: a project using source material from an HDV high definition camera recording in 1080i format.

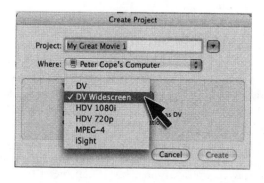

figure 10.3 start a new project: use the drop-down menu to create a new project that will produce a movie of the type required.

Some software will automatically detect the format of the incoming signal and adjust the format accordingly but you can, should you wish, choose an alternative.

When you open the software subsequently you'll be prompted to open this project again (Open an Existing Project) or to create a new one. Some applications may offer an additional option to make a quick movie. Different software publishers use different names for this – Quick Movie, Magic Movie for example – but we'll look at these fast-track solutions in more detail later.

When the software is running it should (and we emphasis *should*) recognize it. In some applications you may have to switch the software to 'Import'. You'll see a message that says 'Camera Connected' or similar.

What importing means

It's worth taking a moment here to mention what importing, capturing or downloading actually means. It doesn't mean transferring the video from the camera to the computer, although transferring is part of the process. It's actually copying the original video to the computer. At the end of the import the original tape in the camera still features your recording. It's a good idea to keep this safe – at least until you've completed your editing. Should anything go wrong, should you delete a section of the recording accidentally, you can re-import the relevant sections from the original.

Connection troubleshooting

We say that the software 'should' recognize the camera as attached because it isn't always the case. This is not due to a fault in the camera or the software and is often described as 'just one of those things'. If your camera is not recognized, before panicking, try the following checks.

- Check that the camera is turned on. It's an easy mistake to make! It's a good idea to have the camera turned off when connecting to the computer, but it can mean that you don't switch it on when ready to import your video. Also, some cameras will, after a period of inactivity (such as waiting for you to start the software and get sorted), switch to standby mode or even go to sleep. Turn the camera off, then on again to wake it up.

- Check the camera is set to the right mode. Even if you have a perfect connection but the camera is set to record (rather than playback), the software will not recognize it being connected. If all software applications have one thing in common it is that they are all equally unhelpful in advising about connectivity problems!

- Connect the camera's mains adaptor. This is good practice in any case, but it prevents the camera powering-down when the battery is low.

- Double check cable connections. Because FireWire connectors don't have any form of locking mechanism they can become either detached or loose, breaking the connection. This is particularly true of the connection at the camera end: moving the camera can sometimes dislodge the connector.

- Be particularly mindful of any special requirements on the part of the camera or the software. Some software applications are meticulous about the order in which camera and software are started. For some software you'll need to have the camera 'on' before starting the software, for others it is the turning on of the camera that triggers a response from the software.

If these diagnostics are unsuccessful there may be a more fundamental problem, one that will need a little more work to solve.

Most common among these is that the software you are using doesn't have a driver (a special small computer program that ensures that your video editing software is compatible with your selected camera) for your camera. If this is the case, or you suspect it to be, pay a visit to the software publisher's website and check compatibility. Publishers' websites include compatibility lists that you can check your camera against. If you find that your camera is supported but still doesn't work, it may be that your software is not the most recent version and will need an upgrade or 'patch'. You can generally download these from the same website.

Still no joy? If you've been through all these checks there may be a fault with your computer. Check the FireWire cable first (to make sure that this is not the faulty component) but then refer the problem to your dealer.

However, be assured that most of the time the camera and software will recognize each other and of the minority that don't, a quick power-down/power-up will do the job.

figure 10.4 camera connected: once contact is established you'll get a cheery confirmation such as this. You can then use the tape playback controls (bottom of image) to control the playback, or hit 'Import' to import the video.

No FireWire connection?

Some cameras don't have a FireWire connection and instead rely on the alternative USB2. This is a problem for many software applications that search for a camera on the FireWire connections. Again, don't worry. Some camera types – particularly those that use hard discs and memory cards – use USB2 almost exclusively and the advice we give later on for these cameras will apply to all USB2-equipped cameras.

Importing your video

With a connection established you are ready to import your video. You'll see the process described as 'capture' in some software – and the terms 'capture', 'import' and 'download' do tend to be used interchangeably, even though purists will describe subtle differences between each. Here's how to begin the capture:

- Make sure the camera is turned on and connected to a power supply.
- Switch the software to Capture (or Import) mode (this is automatic when using some applications).

- Use the tape controls to play your tape to check it's correctly positioned to start importing.
- Rewind if necessary and then click on the Capture or Import control to start importing the footage.

You'll have noticed at this point that the software has taken control of your camera and that you can review the recorded footage, fast forward and rewind through it using the VCR-like keys under the import window display.

Sit back. Importing footage takes place in real time: that is, if you've an hour's video recorded it will take an hour to import. Time was, not so long ago, when video editing software would take almost total control of your computer at this stage and prevent you from doing anything else. That was because the demands of importing your video on the computer's processor and other systems was so onerous that any attempt to do something else on the computer could compromise the quality of the recording.

Nowadays processors – and computers generally – have sufficient capacity to allow other jobs – such as writing and sending emails, web browsing and even word processing – to run alongside the import. However, if you can leave the computer alone whilst it's importing, so much the better. Even with a powerful processor there can be momentary glitches that appear as blank screens or jumps on the downloaded video.

Getting the best imported video

If you notice that there are a number of lost frames when you review your imported video, what can you do? Sometimes, even with a powerful computer, you'll still get a few lost – or 'dropped' – frames but you can minimize this with a few simple precautions.

- Shut down (that is, close) all other obvious applications that you may have running. Even applications that might seem innocuous, such as Word, do tasks (like autosaving) that put momentary strain on the processor and will vie with your video download for processing power.
- Disable or turn off (temporarily) background applications – screensavers, virus checkers. These, too, tend to spring to life unexpectedly, making additional demands on the processor.

- If you watch TV on your computer then that's one task you should leave well alone – downloading one video stream whilst displaying another is too much for many computers and could spell disaster for the quality of your recording!
- Make sure that there's plenty of free disc space on the computer's hard disc and that the disc is as tidy as possible. When your computer is faced with a stream of data coming down the FireWire cable, it needs to be able to write this to the computer's hard disc as fast as possible. If free space on the disc is tight, or fragmented – so the computer has to continually hunt for it – the flow of data can be interrupted.

Monitoring your import

As your computer takes care of the import, you'll notice that the video plays out before you and the software will cut your video into individual clips.

As you watch the video playing don't be surprised if the quality is not what you'd expect. This display is essentially only for monitoring purposes. You can be assured that the quality of the video being recorded on your computer's hard disc is every bit as good as that recorded in the first place.

Our second observation that the video is automatically divided into clips. Every individual scene that we've shot – whether it lasts a few seconds or a few minutes – will be detected by the software. At the start of each scene a new video clip thumbnail will appear on the 'shelf' – a gallery of clips displayed to one side of the software's main display screen. This is a really useful feature that saves us having to chop the film into individual scenes ourselves and makes the whole process of compiling our movie much easier. Surprisingly, this feature is rarely found in professional applications where the splitting of clips is very much a manual task.

This, as we will see, is also a useful feature because it lets us discard unwanted or below-par scenes at a stroke and rearrange the remaining ones in any order that we wish. We can compare this to film editing where individual scenes are cut from the reels of film recorded and physically rearranged. Doing this digitally is far simpler, however!

figure 10.5 clips: whether it's called a **clip shelf**, gallery or something else, this is the feature of the software that makes it so easy to build our movie later.

Should you wish to, you can turn off this scene splitting capability in the software's Preferences, but it's hard to think of a reason why you might want to do this.

Finishing your video import

At the end of the import (again depending on the software application you've been using) the import will stop, or you can stop the process by clicking on the Import button again. Now all the scenes from your video will be neatly arranged on the clip shelf, ready for the next stage, editing. Meanwhile, if you want to take a closer look at any of the clips on the shelf you can do so. Click on one and it'll open in the main window. Use the playback controls (as we did earlier) to play, wind and rewind the clip. Unlike earlier, this time we are playing our copy of the video from the computer's hard disc!

Importing video from a DVD camcorder

The rationale for DVD camcorders was to provide a means of viewing video directly, by taking the recordable DVD from the camera and play it directly in a DVD player. Unfortunately the **MPEG-2** format used to encode the video is not so easily edited. However, most DVD camcorders do come with limited software applications that provide editing facilities.

Alternatively you can transcode (that is, convert) the DVD video to DV and edit as we've described above. To do this you'll need to physically transfer the DVD to your computer and copy the video files (called VOB files) to the hard disc.

Another method, one that is frowned upon by videophiles because of the possibility of losing quality, is to treat the DVD recording as an analogue recording. You can hook up the output from a DVD player to an Analogue to Digital converter (as we describe on p. 192) and import the video in the same way as analogue video recordings.

To be honest there is a drop in quality using this method but it is not marked and is compensated for by the ease of import and the fact that you quickly produce a native DV copy.

Importing video from an MPEG-4 video camera

MPEG-4 video cameras, such as JVC's pioneering Everio range, tend to have USB connectors rather than FireWire. Though they are supplied with editing software applications, many people find these rather rudimentary. Fortunately, the proliferation of MPEG-4 cameras along with the increasingly widespread adoption of MPEG-4 for video productions generally, means that many common editing applications now support it.

Unlike a DV camera, when you attach an MPEG-4 camera to your computer its hard disc will appear to the computer as a conventional hard disc: on a Macintosh it will appear on the Desktop, on a Windows PC you can find it in My Computer.

figure 10.6 the camera's hard disc (or memory card) can appear on the computer's desktop or be revealed by selecting 'My Computer' on Windows PCs. Contained within is the video file that you'll need to import.

You can open the hard disc icon and import the video file contained within to your editing application. Depending on your application you can either drag and drop the file to the software or use the software's Import command to import it directly. If you don't plan on editing right away you can copy this file to your computer so that you can wipe the disc on your camera ready for your next production.

When you do come to import your video you'll find that your footage will be imported as a single clip, rather than being broken down into clips as with DV footage. You can, as we'll see in the next chapter, do this manually. Also, you won't be able to use the capture controls in the software to control the camera.

Memory card cameras

Video from cameras that use removable memory cards and microdrives can be downloaded in exactly the same way as those that have fixed hard drives. Where available these cameras can be connected directly to a computer, in which case the hard disc will appear on the desktop in the same way as we have described above. For those that don't have connection capabilities you can remove the memory card and place it in a card reader – such as those that you might use with a still digital camera.

figure 10.7 memory card and reader: memory cards are often more easily read (and the data downloaded) by using dedicated card readers.

Importing high definition (HDV) video and multiple formats

In general – and it can be a bit of a sweeping generalization – you can download HDV video into your application in exactly the same way as conventional DV. As you may have noticed when we were discussing software applications, or when you were shopping for suitable software, many of the key applications now support this recording format. To make absolutely sure that there is no ambiguity many now feature 'HD' in their names (for example 'Final Cut Express HD') to reinforce – to those of us not in the know – that they are compatible with high definition both in terms of downloading and editing.

HDV uses a special method of compressing data called MPEG-2, to compress the data sufficiently to pack it onto a standard DV tape. Though the technicalities of this are beyond the scope of this book (and beyond the scope of all but the most dedicated technophile) MPEG-2 is the same format as is used for writing video on to DVDs.

Most movies that you produce will use a single camera for all the shooting. For some productions, though, you might want to use material from more than one source. A good case in point might be a family history: you may have some great digital video shot on your new, widescreen digital video camera, but you

want to combine this with some older digital video, some analogue video which you shot in the 1980s and maybe even some cine films that predate all these.

You can combine all these in the same project by importing the resources using the method most appropriate. Your DV recordings can be imported directly from the camera while analogue material can be via a converter. Film too can be imported (see Chapter 14). You can even import HDV material into a standard definition project. In the latter case the high definition material will be converted – as it's imported – into standard definition.

Where the screen formats vary, different source material will be letterboxed or displayed with side pillars as appropriate.

Images and audio

Your final movie is likely to be built around your imported video footage (of whatever vintage), but you might also want to include images and music – as part of the soundtrack. You don't have to do anything special to prepare these for use – you can import the images or audio material as you would any other images from your digital camera or music collection. We can navigate to the appropriate directories when we need them later.

Summary

If you've made your way through this chapter you'll know all the ins and outs of importing video to your computer. You'll be aware of, and able, to import addtional resources too, such as images and music.

Downloading is normally a straightforward process but, should the worst happen and you're not able to download, by following our troubleshooting guide you will be able to analyse and isolate potential problems.

figure 10.8 a and b letterboxing and pillarboxing: mixing formats will result in letterboxing or pillarboxing, as illustrated here.

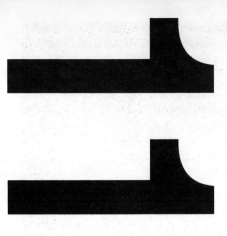

essential editing skills

In this chapter you will learn:
- about the key editing tools provided by your software
- how to start cutting and assembling your footage
- some useful shortcuts to producing a ready-to-watch movie.

Editing, if we cut to the chase, is the process of choosing what we want to include in our finished movie, what we want to discard and then assembling the resultant footage into a single length – metaphorically in the case of digital media – of film.

Great editing is often promoted as an art as well as a skill because it requires both the mechanical ability to cut, trim and manipulate scenes and also the vision to put the refined scenes together to produce a polished and meaningful movie.

A practical note

This book would become needlessly repetitive if we repeated the instructions precisely for every video editing package you're likely to encounter. Instead, we'll look more generically at the processes involved. Whether you are using applications such as VideoStudio or iMovie you'll find the processes involved identical; only in the detail and the 'look' do they vary.

In-camera editing

Before we explore how we can gain the skills – and develop the artistic eye – for video editing it's worth mentioning another form of editing: in-camera. In fact there is nothing mysterious about this technique at all and it's the one many of us – particularly when we're exploring video photography for the first time – instinctively use.

In-camera editing simply involves shooting scenes in our video in the sequence that we intend to replay them. Once we get to the end of the production we can copy the tape and that's it. As a methodology it's sound in principal but weak in execution. Shooting with the aim of using all the footage shot without any further modification makes several presumptions:

- that we have been able to shoot everything in sequence
- that every scene has been shot perfectly
- that we have made no mistakes.

You'll probably have realized by now that the chances of not falling foul of at least one of these is negligible. Okay, so for a short, informal video some minor rough edges might be forgiven by an accommodating audience, but as our aspirations grow we quickly realize that in-camera editing is never going to be satisfactory.

Besides, shooting everything in-camera prevents us from further refining our production by the inclusion of, for example, titles, transitions – elegant links between scenes – and special effects. No, it's probably worth acknowledging that editing in-camera will work to a point, but that point will never be close enough to satisfy our increasing demands.

Digital non-linear editing

A big name for a powerful process – editing movies on our computer. We've accomplished the initial stage of this – importing the source video material already – but now we need to set about creating our movie. The term 'non-linear' sounds impressive but actually only describes editing where we can select and choose video clips (to build our movie) from anywhere in the source material. And by virtue of the fact that our software has automatically cut our video into individual clips during the import, our free hand in selecting clips in any order is assured!

Your first edit

Before we explore the stages possible in non-**linear editing** (or **NLE** for short), let's see how easy it is to create a movie from our clips. To do this we first need to familiarize ourselves with the key elements that make up the video editing software's interface. These are shown in Figure 11.1.

figure 11.1 timeline

1 *The preview window*: this is where we saw the imported video playing and where any selected clip – or clips – can be previewed. We can also preview our embryonic movie as we assemble it. The controls below the screen allow us to play and review clips.

2 *The clip shelf*: clips automatically produced on import, or cut subsequently from longer clips are displayed here (some applications will show these as filenames rather than thumbnails).

3 *The timeline*: this is where we build our movie, by dragging clips from the shelf. Later we'll see that we can also drag other resources here and manipulate them too.

4 ***Scrubber bar***: below the preview window, this represents the clip displayed. As we play it a marker – the **playhead** – moves along the scrubber bar. If we want to take a look at the mid point in the clip, timewise, we can drag the playhead to the mid point of the scrubber bar.

The timeline, we should note, has something of a split personality. Sometimes it can be used to show the thumbnails of clips, at others it can be switched to show an accurate timeline – where clip lengths are proportional to their duration (see Figure 11.2.

figure 11.2 timelines: thumbnail (clip) format upper, timebased, lower.

The layout of the software interface will vary according to the specific application that you are using but the basic elements remain the same and will operate – or interact – in exactly the same way. And, as you might expect or have seen for yourself, there's much more to explore in the interface. But, for now, and for our first edit, we'll leave those well alone.

Start your edit by clicking on a clip on the clip shelf. Drag it to the timeline and drop it. That's it! You've placed your first clip into your movie (see Figure 11.3).

figure 11.3 dragging clip to timeline.

If you click on the clip now it will appear in the preview window and you can control the playback using the buttons below the screen. Simple, but that's our movie!

Of course, unless we've shot our whole video as a single scene, that movie would be very short as it stands. We need to add more clips to produce something more meaningful. Drag another clip to the timeline and drop it on.

Now you'll see two clips displayed, side by side. Add a third (see Figure 11.4). Now we have a choice. We could drop that clip in place after the two we've already placed. Or we could drag it to the start – front of the clips – and drop it there. We could even drop it in between the two.

figure 11.4 third clip being dropped on timeline.

Clips don't need to be dropped into a specific place. Once you've dropped some clips on the timeline you can move them around at will. To do so, click on a selected clip and drag it to the position you wish to place it in the movie and drop (see Figure 11.5).

figure 11.5 rearranging the clips.

To review your movie again, click on the Play button. Now the preview screen will display all the selected clips consecutively.

Editing: getting serious

Okay, so we've seen how easy it is to assemble a collection of clips into a movie. Where do we go next? Just as it's pretty unlikely that you'll successfully edit a movie in-camera so it's equally unlikely that you'll be able to put together a polished movie by dragging and dropping your video clips to the timeline. Movie making needs a little more thought and then, a little more work to get it into shape.

A structured approach to editing

Being methodical is the key to getting great results with the minimum of fuss. Professional editors work to very precise plans for their movies, but we can be a little less strict. Here's a suggested schedule.

Review clips: take a look at each of the clips in turn, checking them against a script or shooting plan if you have one. You can do this review when the clips are still on the clip shelf. You may find it helpful to rename your clips when they are on the shelf so that you can more easily locate them when you come to build the movie.

Drag the clips into a rough edit: before starting work on any clips, string the clips together as a rough edit. This is done by assembling the clips on the timeline (as we described earlier) but in the order required for the finished movie.

Assess the rough edit: watch the movie in its rough form and assess it now as a whole. See how scenes link together and think how the flow might be improved. Some of your clips can be discarded because they are technically deficient, are not required for the movie or are, perhaps, duplicated. If there's no reason to keep the clip, discard it now by deleting or dragging to the trash. Some clips will be fine and need no further work, but some can be identified as needing some remedial work, such as trimming off a beginning or end.

Edit clips: on the basis of your reviews you'll find some clips need to be modified in some way. This may involve anything from splitting clips into two to culling frames selectively from the start, end or centre.

Assemble movie and embellish: To complete our movie we can add transitions to link clips and scenes together, add titles where appropriate and work with the audio tracks. We'll explore these later.

Editing clips

It's the editing of clips that we now need to explore in a little more detail. Sadly, even if we've successfully strung all our clips into a movie we will still need to edit each individually. No need to return them to the shelf, though, we can work on them where they sit.

Splitting a clip

Here's an easy start in editing: splitting a clip in two. You might ask, why would you want to split a clip? Well, it's a convenient way to cut away a superfluous section of a clip or can be used as a preamble to removing material in the centre of a clip. You'll see later that splitting a clip is a useful way of applying titles to a clip, or rather, to part of a clip. By splitting the clip first you can construct a title to fade in and out only on the split part, rather than the entire clip.

- Start (as with every edit) by selecting the clip by clicking on it.
- Move the playhead along the scrubber bar to the point where you would like to split the clip (see Figure 11.6).
- Select the command 'Split Clip at Playhead' (see Figure 11.7).

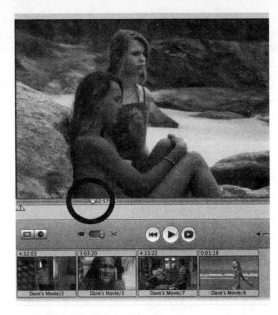

figure 11.6 splitting the clip.

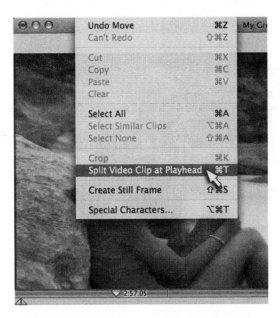

figure 11.7 selecting the 'split clip at playhead' command.

If you check the timeline you'll notice that now you have two clips where there was previously just the one. Were you to play the movie now, both clips will play seamlessly after each other in exactly the same way as before the split. But you can now, should you wish, delete one of the clips (see Figure 11.8).

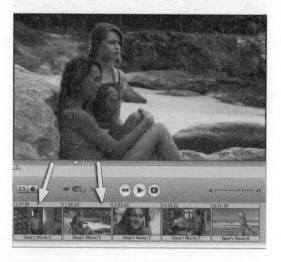

figure 11.8 splitting a clip: one clip is now represented by two on the timeline.

Cropping a clip

Cropping is a term taken from trimming photos – it involves cutting sections from the start or end (or both) of a clip.

- Select the clip to crop.
- Move the playhead in the scrubber bar to the point where you'd like the scene to begin (in movie making terms this is sometimes called the 'in point') (see Figure 11.9).
- Put the mouse pointer just below the playhead and drag it to the right until you reach the point where you want the scene to end (the out point). Markers, called 'crop markers' will appear and define the in and out points (see Figure 11.10).

figure 11.9 selecting the 'in point'.

figure 11.10 the crop markers.

- The selected part of the scene is normally shown highlighted.
- Select Crop from the Edit menu to perform the crop.

It can often be problematic to select precisely the right frame that you want to use as either the in or out points. Most applications have keyboard shortcuts that will allow you to move the playhead by predetermined amounts – such as ten frames at a time and then one frame at a time, for accurate frame positioning.

Deleting a clip

If you want to remove a clip entirely from the timeline you can either drag the thumbnail to the trash area, drag it back to the clip shelf or select Cut from the Edit menu.

Taking a step back

If you realize at any stage that an edit you've performed is incorrect (or you want to revert to a previous edit stage) you can select Undo from the Edit menu and move backwards, stepwise through your recent edits.

Some applications will allow you to move backwards almost without limit though some will only allow you to backtrack through the edits you've undertaken in the current session (that is, since you last opened your project).

There are also more powerful commands offered in most applications such as

- Revert Clip to Original – undoes all edits on a selected clip
- Revert to Saved – undoes all edits on a selected clip since the last time the project was saved.

Safety notice: deleting and trimming

Those of us who have discovered digital video editing after cutting our teeth in the cine world may be concerned at talk about deleting clips. It can get more scary when we begin to think about cutting, cropping and trimming clips too. You'd be right in thinking that we risk losing valuable material for ever in doing so. But here we have the advantage over the film-based editor, in that our material is not lost when removed.

When we delete a clip it's stored in a trash area within the application. So, unlike material thrown to the desktop trash or recycling bin, it will only be deleted when we specifically empty that waste. It's a good idea, therefore, to keep material in this bin until your project is complete unless you are absolutely sure that you will not want it again. Even then, you can always re-import material from the original tape or disc.

Totally non-destructive editing

Some applications go one step further and allow non-destructive editing where we don't consign parts of clips to the bin, we merely hide them on the timeline. This is a great way for us to get our edits spot-on, especially when we're new to the game.

Let's take a look at how this works, using iMovie's interface as an example. Suppose we have a clip containing some material we consider superfluous. The clip is 30 seconds long and we

would like to trim away the first eight seconds or so, where the children are just talking among themselves.

Select the clip in the timeline and ensure that the timeline is in timebased format rather than thumbnail.

Position the mouse pointer at the end of the clip (the right-hand edge) and drag it to the point where you'd like the clip to start. You will now see the first frame of the trimmed clip displayed in the preview window.

Hold the mouse pointer over the end of the clip until it changes into a vertical bar with arrows.

Drag this pointer – along with the edge of the clip – to the playhead.

That's it. Your clip is now trimmed. The best bit is, though, should you later find that you need to retrieve some of that lost footage you can do so by either using the Undo command (for an immediate correction) or by extending the clip back to the full (or an intermediate) length by dragging one of the edges.

Summary

As you work your way through your clip-editing you'll be taking a big step towards producing a coherent movie. We've now gained the technical skills to support the creative skills that should, by now, be developing well. The mechanics of editing that we've explored in this chapter are more focused on getting our embryonic movie into shape. It's the video equivalent of a diet plan. But, as dieticians will advise, trimming away the fat is only the start. Next comes the muscle building and getting into all-round good shape.

For us, that means looking at the flow of the movie more closely and considering how, via suitable transitional effects, scenes hang together. We'll also take a (sometimes) critical look at both titling tools and special effects and how these should be used.

12

adding transitions, titles and special effects

In this chapter you will learn:
- about the need for, and implementation of, transitions
- when and how to use titles
- what special effects are and how they can be used.

When we review our edited movie we should be pleased, with all due modesty, that we've successfully trimmed away all superfluous and below-par material. A comparison of pre- and post-edit footage would instantly reveal the latter to be a much-enhanced offering. So, in editing terms, is that it? By virtue of the fact that we're even asking this question you'll have guessed not!

Transitions

Since the earliest days of the cinema, directors and editors have realized that a simple 'cut' (whereby one scene ends on one frame and the following begins on the next) can be too abrupt for all scene changes. Cutting back and forth, for example, between shots of two subjects can produce a stretch of video that appears visually to be very fast paced. If the subject matter of those scenes is not intended to be so, then this can lead to poor video. So, what is the solution? Transitions.

For both examples and exemplars here we can turn to professional movies and television. Spend some more time watching some movies, drama and documentary. Take a look at how shots and scenes are linked. News, and most current affairs programming, will generally feature simple cuts between all scenes. This is a consequence of the live (or recorded-live) nature of most material used in these programmes.

Transition types

Things get a little more interesting when we explore other genres. Drama, especially, makes creative use of different transition effects at different points in the production. Here are the most common transitions that you'll encounter. Take a look at the description of each and see if you can identify them:

Cut: the default-type transition with the instant change from one shot to another. It is still the most common transition in all productions.

figure 12.1 cut.

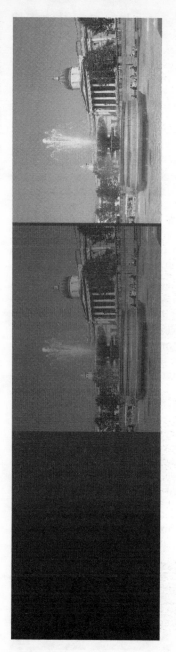

figure 12.2 a and b fade in; fade out.

figure 12.3 crossfade.

figure 12.4 horizontal wipe.

Fade in and fade out: a shot fades in from, or out to, a single colour, usually black. Often these are known as 'fade from black' or 'fade to black'. They are generally used to open and close a movie, or to open and close major scene changes.

Crossfade: also known as the mix or **dissolve**. They describe a transition where one scene fades into the next so that, at the mid point, both the finishing and starting scenes are visible. You'll see these being used to suggest the passing of time or as a way to link scenes shot in different locations. It is also regarded as a soft fade – it helps to lead one clip leisurely into the next.

Washes: often lumped together with fades, washes work in a similar way but fade to and from white rather than black.

Wipe: a more obvious transitional effect where a scene is progressively replaced horizontally, vertically or even diagonally. A variation on the wipe, the *push* sees the new shot push the old one off the screen.

There are many more transitions offered by most video editing applications but you'll probably – after a modest flirtation – find these are too overt and lack the subtlety of those described above. By all means use them if you think they will contribute to your production, but be aware that transitions, carefully used, should not be at all obvious to the viewers.

When to use a transition

Rather like special effects filters provided with image editing software or the transitions offered by presentation applications such as PowerPoint, we tend to abuse transitions, applying far too many and erring towards the more extreme types rather than the more subtle. The results are often spectacular visually but add nothing to the quality of your video and undoubtedly make it uncomfortable to watch. Viewers will be awaiting the next bizarre transition rather than enjoying the movie.

Before applying a transition ask yourself

- Why are you applying the transition?
- What is the intention?
- Does the chosen transition serve a purpose – for example, progressing the story or smoothing the link between two scenes?
- What transition can best achieve my objective?

The answer to the final question should be, for the majority of transitions, a simple cut. Only add an alternate where there is good reason to do so.

In-camera transitions

When we shoot shots with our camera each is linked to the next by a simple cut. Some cameras, though, offer in-camera transitions. Maybe not a large selection – a crossfade, fade-ins and -outs and a couple more – but enough to entice you to use them.

These may appear to be convenient: you can do some of the postproduction while still shooting. Consider this more closely and you'll see some major pitfalls.

- When shooting you need to concentrate on getting the best quality footage: holding the camera steady, framing correctly and so on. Activating a fade control diverts your attention.
- With a transition burnt into your footage you don't have the opportunity to remove or refine it later.
- Transitions recorded with your footage don't give you the flexibility to edit the footage at will later.
- If the transition is wrong – either the wrong type or runs at the wrong pace – you can't do anything about it.

The upshot of this is that it's a bad move to use in-camera transitions. Leave them well alone!

The mechanics of adding transitions

You can add transitions to the start or end of any clip. There is an obvious caveat – only certain transitions – fade-in and fade-out, for example – can be used with the first and last (respectively) scene of any production.

There's also a practical point to bear in mind. Some transitions, as you'll discover when you come to know them a little better, eat into the footage of the clip to which you apply them. That means that you could find that when you apply these transitions the clip can be shortened slightly. As your awareness of this grows you'll learn to allow extra time in the clip when editing, to compensate. This is also a good advertisement for non-destructive editing methods – you could retrieve trimmed (but not deleted) footage to allow for the transition.

Here's how you add a transition to link two clips.

1 Drag the playhead to the area of the movie near to where you want to add the transition and identify the two scenes that you want to link.

2 Open the Transitions pane (in iMovie you'll find this by pressing the Editing button, in other applications click on the Transitions tab).

3 Select a Transition style to preview it.

4 Depending on your application, either drag the selected transition to the join between two clips or click on the small rectangle between two clips to activate it.

Many transitions offer a degree of control. Duration, for example, can be varied so that a fade can be adjusted to be fast or slow according to need. You can generally preview the effect (and any modifications made) either prior to, or after, applying. You can then make whatever changes you need – or even remove (or replace) the transition.

Rendering

When you apply a transition, and also when we add special effects and titles, it's rare for the changes involved to be directly applied to the video footage. A transition or special effect involves quite a bit of modification of the video files and this does take some time. This process is known as rendering and for any task can take between a few seconds and a few minutes to complete.

You'll get a visual cue as to the progress of the rendering, but usually you can leave the rendering to progress as you get on with other tasks. Only if you were to try and work on a clip being rendered (for example, trying to add a transition to a clip where a title is currently being rendered) will you find your path temporarily blocked.

figure 12.5 rendering in progress: here a bar along the bottom of the icon representing the transition shows the progress of the render.

Titles and captions

Often considered the mark of a professional video and something that distinguishes such from casual movie productions, titles can be an important feature of your movie. Some directors, though, take an opposing view, suggesting that if your movie has been properly structured – with strong establishing shots to open and a powerful storyline – there is no need for any type of titling. In practice, though, you'll find that sensible use of titles (a term that we will use here to describe opening titles, sub-titles and end credits) can add much to your movie.

The rationale for titles

Why should we use titles? That may seem a somewhat obvious question: we think of titles 'announcing' our movie and, in a sense, naming it. But titles have much more subtle uses. Here are just three:

- to act as the final flourish to define a finished production, giving the professional finish
- to describe to our prospective audience situations that are not immediately obvious
- using a theatrical term, to divide a production into clearly defined 'acts'.

Creating titles with your video-editing software

Like transitions, video-editing software provides a wide range of titling tools to help embellish your production. And like transitions, some of these are sober and workmanlike, others more extreme or downright wacky. There are no hard and fast rules for what your titles should look like, but based on the experiences of movie makers over the years, there are a few guidelines that will help us produce better-designed titles. More importantly, they help us produce titles that are better received by our audience.

Length: keep your titles short and use as few words as necessary. Consider a movie we've made of a family holiday to the Caribbean. A good title, superimposed over a shot of a Jamaican beach might be 'Jamaica 2007'. Combined with the background shot this says enough; our audience can read and take it on board in an instant. Saying something more longwinded such as 'Our Family Trip to Ocho Rios in July 2007' is too cumbersome. As this is a family movie, and the exact location is explained later, these bits are superfluous.

figure 12.6 a and b short titles are always preferable to longer.

Duration: how long should the title remain on the screen? The rule of thumb is sufficient for it to be read through twice, slowly. That can be a bit proscribed and, for a short title, can be too brief. For most titles, once they have appeared completely on the screen give them at least five seconds. Preview the title and see if that is sufficient. If not give a little more time.

figure 12.7 a and b a good-sized title in an easy to read font will always win over a smaller one.

Size: make your titles big. It makes them easier to read. So often you see titles that are too small. The upshot is that the audience struggles to read them and rather than being something that helps with the storyline they are something that interferes with the continuity. Okay, so you can go to the opposite extreme and stick up some frame-filling giant captions too. These, used correctly, have terrific impact but need to be used carefully and where you want to make your audience sit up!

Font: your video editing software will normally have access to all the fonts on your computer. This is something of a mixed blessing – it gives you plenty of choice for sure but many fonts are totally unsuitable. That's not because they are bad fonts, it's just that when viewed on a television screen those fonts with narrow risers (such as the verticals in letters such as 'L' or 'N') and serifs (the flourishes at the tips of letters in some fonts) become harder to read, especially when in a smaller font size.

This still leaves plenty of fonts to choose from. Bear in mind that sharp blocky fonts such as Arial and Verdana impart a modern feel; Gothic-inspired fonts are good for period pieces and horror; soft edged fonts (Comic Sans, for example) are good for informal films or videos about children.

figure 12.8 a and b beware off-beat fonts. They just don't work on a TV screen.

Colour: just as you can choose any font or size for your titles, so those titles can be any colour. Aim for a colour that blends well with the predominant colour of the background and also stands out. Some colour combinations are bold: think of blue and orange, or maybe yellow and indigo. Try to avoid a title in these colours when the predominant background colour is the other; what is mildly garish in print becomes vibrantly so on screen. If in doubt, go for black, white, or a primary (blue, red or green) colour.

Of course, the great thing about digital video editing is that you can trial any combinations of colours, fonts and sizes until you get something that both looks good and is appropriate for the movie.

Movement: titles need not be static. They can move! Think of the Superman and Star Wars openers where titles zoomed in and out respectively. Or those end credits that run right to left across the bottom of the screen. Your software will allow you to do all this and more!

Like other techniques though, less is most definitely more when it comes to movement. A gentle fade-in and fade-out is easy on the eye and succinct. Remember that titles should add something to the movie as a whole and should not compete for attention. Be particularly careful with those right to left rolling credits: **compression** techniques on video and reproduction on some television screens can render these unreadable.

figure 12.9 zooming fonts work well with an appropriate subject.

Of course if there's a reason to break the rules, do so. For example, if your movie opens with a group of children (or maybe adults) playing on a bouncy castle, titles that bounce their way in (a technique generally frowned upon) might be just perfect.

In-camera titles and titles on location

You can add titles to footage as you shoot using the titling features found in many cameras. We can reiterate the advice we have given earlier with regard to other in-camera effects. Don't do it. Titles generated by a camera tend to be rather proscribed and unimaginative. This is something not lost on camera manufacturers – whereas most cameras would, at one time, offer this feature very few now do so.

However, titles shot on location are quite a different matter. Shooting titles that can be used – at the editing stage and in place of computer-generated titles – is something that you should continually bear in mind. What do we mean by location titles? Anything from a village sign, theme park entrance or even a notice board. Even ephemera – such as tickets to the theme park, air tickets or an event programme – can be the basis of a great impromptu title. In fact, anything that delivers a message – unambiguously – to your audience is ideal.

Location titles are often better received by your audience because, like well-conceived transitions, they are low key, progressing the movie storyline without compromising integrity.

figure 12.10 signposts make for convenient location titles.

Special effects

Some movies today only exist thanks to special effects. Landscapes, environments and even some key actors are just special effects added at the postproduction phase. And it's not just the obvious genres. Just about every major movie today boasts a collection of special effects (or CGI – computer generated imagery) seamlessly integrated.

Why? Two main reasons. The first, and perhaps most obvious, is that special effects allow us to build complete worlds that would otherwise exist only in our imaginations and have actors – and actions – existing within them. These are the hyper-real special effects.

Other effects, perhaps more mundane by comparison, are used for cost considerations. It's more cost-effective to have your actors based in a studio sound stage and simulate a desert environment, for example, than to pack the whole cast, kit and caboodle off to the Mojave or Sahara deserts.

The special effects that our video-editing software offer are, let's be honest, even more pedestrian. However, that's no bad thing. These effects are specially designed to enhance and embellish the real-world footage in our movies. Some can help us correct deficiencies (whether due to accident or circumstances) in our original footage. Others are more specific and more overtly 'special'.

Enhancement effects

In the former group, which we might call enhancement effects, are those such as Adjust Colours, Brightness/Contrast and Soft Focus.

Adjust colours: this allows us to vary the colours in our video. Rather like crude controls found on some old colour televisions, we can shift the hue (that is the colour tint) from a cold blue through to a warmer red. This is useful when trying to match scenes. Imagine you shot some scenes in the late afternoon. Towards the end of your shooting session you shoot a scene that needs, during the editing, to be placed earlier in the sequence. The chances are that the sun would have been lower in the sky for that shot, imparting a warmer colour. By adjusting the hue to a cooler setting we can even out the variations.

A colour control lets us alter the colour saturation. Anywhere from desaturated (that is, black and white) to vivid, oversaturated. Often you'll also find a brightness control too. You can also use this as a balancing tool.

Brightness/contrast: a brightness control also features on this special effect along with a contrast slider. Sometimes when we shoot in bright sunlight (especially when the sun is high in the sky) we can get results that are unusually contrasty. Nudge the contrast slider down a touch and you can get more balanced results, with shadows brightened a little and highlights suppressed. Use this slider in concert with the brightness control in order to keep the brightest parts of the image bright.

Soft focus: this is the one for those romantic movies. Apply soft focus to a scene and it adopts a dreamlike quality. This is quite different to an out-of-focus shot: soft focus maintains the sharpness of the original scene but diffuses all the highlights to give a soft hazy appearance. Some soft focus effects further enhance this by giving the diffused highlights an additional glow. Definitely one for the romantics.

Sharpen: there's no excuse for shooting blurred movies. Autofocus mechanisms while not foolproof, are capable of delivering sharp results 99 per cent of the time, but even when you shoot good images they may not be critically sharp. Apply the sharpen effect and the perceived sharpness of your video is increased. 'Perceived sharpness'? You haven't made the image any sharper but by some digital sleight of hand (increasing the contrast at detected edges for the technically minded), we get a result that is, to all intents and purposes, sharper.

As with all special effects, when you've applied the sharpen filter you should observe the results by reviewing the video footage to which the effect has been applied. Particularly when you are using an effect for the first time, it can be easy to overdo. It's best to assess and correct now rather than after you've completed your movie and, say, burned it to DVD.

Sundry effects

Along with the worthy enhancement effects there are a diverse and somewhat eclectic collection of effects. These are not designed to enhance the video per se, but in the tradition of theatrical special effects, augment your video. This selection varies with application, but here are just a few of the more useful you'll find on offer.

Fog: (Plate 10) no surprises here. Simulates a foggy scene. You can vary the amount from a heavy pea-souper to a light haze. It's best used at a moderate (say 30 per cent) setting. Too little gives the appearance of a misted lens, too much can degrade the image.

Rain: (Plate 11) this weather filter adds a light shower or tropical downpour to a scene. It is a competent effect but results depend on the scenes it is being used for: avoid incongruities of bright scenes and heavy rain!

Aged film: it can be clichéd but 'Aged film' makes your movie look like an old and abused piece of cine film. Useful where you want to imply that a scene – or scenes – were shot years (or, rather, decades) ago. To effectively simulate old style film you can vary the amount of jitter and scratches on the film, too.

figure 12.11 aged film effect.

Lightning, electricity: staple of the horror movie, a streak of forked lightning. You've a fair degree of control over the look – number of branches, duration and so on. Electricity is a variation on the theme that delivers a more continuous stream of electrical discharge from a selected point.

figure 12.12 lightning effect.

Flash: for sheet lightning, or to simulate the effect of a paparazzi posse.

Earthquake: I don't suppose too many of us make movies featuring earthquakes (and we're often more concerned with removing shake from our shots) but if you want to suggest violent shaking – horizontally, vertically or a combination of the two, here's the idea effect.

Ghost trails and fairy dust: from the proverbial sublime to the ridiculous. Faintly ridiculous, perhaps, as these are examples of effects that continue to be popular. Ghost trails gives any moving subject an ethereal trail – combine it with slow motion effects and maybe soft focus for the ultimate in dream scenes. Fairy dust sends a digital version of Tinkerbell across your scene. Children's birthdays and Christmas seem the most popular use of this one!

Special effects timing

Timing is crucial for some special effects. Okay, so some – like our slightly arbitrary collection of enhancement effects – tend to be used for a whole shot or scene, but others need to be applied more specifically. For that reason all special effects allow you to set an Effect In and an Effect Out time. This is the time,

measured from the start of the clip, where you want the effect to start and finish.

Summary

Through this chapter we've looked at three movie features, transitions, titles and special effects, that can be used to enhance your work. You'll probably find that you'll use transitions in virtually all of your productions. The sparing – and we mean sparing – use of fade-ins, crossfades and the like will help with the flow of your movie and make it a more enjoyable experience for your audience.

Titles will, most likely, be used in a number of your productions where there is a need – where the subject matter demands it. Similarly with special effects. Resist the temptation to justify using them throughout your movie and employ them only where correction is necessary or you need a dramatic flourish. We used the adage 'less is more' earlier; keep this in mind as you reach – with your mouse – for the titling and effects buttons!

13

working with sound and additional sounds on your movie

In this chapter you will learn:

- how to add sound to an existing movie
- how to edit the soundtrack on your movie
- about sound effects.

From the earliest days of the cinema movie directors have realized that the soundtrack is of crucial importance in any movie. Even in the heyday of the classic silent movies the role of musical accompanist was prized because the cinema and audience acknowledged the value of a good accompaniment.

Adding sound to an existing movie

When you view your movie using the timeline you'll see that, below the line representing the video clips there's at least one audio track. Normally, these will be completely blank. The soundtrack that you've recorded with your video is included on the upper track. With two additional audio tracks you've the capability to have three concurrent soundtracks. These might be the original sound along with, say, musical accompaniment on the next track and a narrative on the third. To avoid these becoming a jarring cacophony we need to edit and manipulate the soundtracks so that they work – figuratively and actually – in harmony.

First, let's take a look at how we can add additional sound to an existing movie.

Adding music

You don't have to add music to a movie to make it successful. In fact, there are a number of cases where improperly chosen or incorrectly placed music can at best prove distracting and worst, shatter the mood. Inappropriate music can also create – unintentionally of course – high comedy where there should be high drama. However, some movies undoubtedly gain from some background music, either throughout or at selected points.

Choosing music – and staying legal

When you are creating your movie you'll probably have a good idea of what music would be best as an accompaniment or useful as incidental music. Indeed, you may have been inspired to produce your own music video based on a favourite piece. If so, now is time to take a deep breath.

There's nothing stopping you adding any music to your video, but beware the strict copyright laws! While there's nothing to prevent you making a music video of tracks from your favourite

artist or using appropriate music for your other productions
you'll need a licence if you want to share that movie with any
audience other than immediate family. Or if you want to show
it anywhere other than home. And, to be honest, getting that
licence is not worth the time, effort or the cost.

Royalty-free and stock music

So, do you resign yourself – should you have big ambitions for
your productions – to having them *sans* music? Not at all! They
may not have the cache of other musicians and performers, but
there are bands and orchestras who make quite a respectable
living from producing music designed to be used by others. So-
called royalty-free music doesn't require any form of licence for
use – instead you purchase the music you want (either track by
track or in collections, usually on CD) and have a tacit licence
to use it freely in your production. Similarly you can find stock
music – rather like stock images – that can be purchased for a
specific use.

Composing a new score

Compose your own score? Not as absurd a suggestion as you
might think. You might be devoid of any musical talent
(something the author can empathize with) but music creation
software can help you quickly put together rhythmic loops and
melodies that you can safely promote as your own music.

You might think that music based around simple loops that
repeat ad infinitum are likely to become boring and (almost by
definition) repetitive. But study any major soundtrack – from
Star Wars, or perhaps *The Godfather* – and you'll see that the
main melodies repeat in exactly the same way.

GarageBand – part of the iLife suite on the Macintosh and
Sony's Acid series are great examples of loop-based software
and each has many devotees who would previously have
eschewed any interest – or skill – in music production.

figure 13.1 music generation software: with just a little practice you can create some great original music using applications such as GarageBand.

The mechanics of adding music

Sidestepping any contentious issues of copyright or the quality of home-produced music, let's take a look at how we can add music to our movie.

The process, you'll be pleased to hear, is pretty straightforward. In fact, in most cases it's as simple as drag and drop. Music, like video clips, transitions and special effects, are treated by our video editing software as just another resource and can be accessed by selecting the appropriate button or tab. You can then identify and select your chosen track and drag to the timeline. And that's it?

Well, very nearly. If you are working with some low key background music you can have it play out exactly as intended: in the background. Background music, by it's very nature, is not designed to interact with the action on the screen and so the precise postioning of the music is not important. The only changes that you might want to invoke is a fade-in at the beginning and perhaps a fade-out at the end. And you might want to consider fading the level a little when there is conversation on screen or when a narrator is speaking.

Other music – incidental music for example – needs more careful placement. You need to ensure that key parts – the start, end or an appropriate crescendo – are linked to the relevant point or points of the action. We'll look at how we do this later in this chapter.

figure 13.2 adding music: music – and sound effects – can be dragged and dropped to the timeline. You can fine tune the position to get the right start or end point.

Adding sound effects

A clap of thunder, round of applause or hysterical laughter. What do they have in common? They are all events that can have a significant impact on your movie, but without the audience necessarily seeing the source of the sound. Sound effects are a powerful way of empowering a movie and are especially useful in that we don't have to think about them at the time of shooting!

A broad (and sometimes eclectic) collection of sound effects can be found in just about every video editing application. You'll have all the staple effects – the laughter, applause, train whistle (how many of us actually need that one?) and many more. As ever, use sound effect sparingly. The gratuitous use of canned laughter (that is, a laughter sound effect) is regarded cynically by any audience when used on a TV comedy. So it will be if you overuse any effect in your movie.

figure 13.3 choose an effect: video editing software features galleries of sound effects from which you can choose.

figure 13.4 sound effects: sound effects can be drag-and-dropped to an audio track. Though not advised, you can have sound effects on multiple channels playing out concurrently.

Third-party sound effects

As well as the sounds included in your video-editing software you'll find the web awash with additional effects either designed to integrate directly with your software or able to be imported into your application. These can be useful for those slightly unusual sounds – the paddling of a gondola or the burner of a hot air balloon – that never make it into mainstream applications.

Such collections are varied both in terms of sounds offered and price. Think hard before spending too much money on a specific set. Do you need all (or at least a few) of the sounds? Does the cost justify the improvement brought to your movie? Could you create the effect yourself?

Adding a voice-over

There can be a temptation to record a commentary as you are shooting. Don't! Recording audio in-camera, at the time of shooting, is fraught with problems. First off, aiming to do at least two things at once means you'll be unable to devote your attention fully to either. When you record your commentary, your emphasis on getting the words right will undoubtedly compromise your ability to shoot first-rate footage.

Second, like special effects added at the time of shooting, your commentary will be indelibly burnt into the recording. If you did fluff your lines or – unnoticed at the time of shooting – you said the wrong words, there's not much you can do about it. Any remedial action – save for recording a totally new soundtrack altogether – will be all too obvious.

The best policy is – should you want to add a commentary – to be mindful of the content and duration of the commentary and shoot footage accordingly, perhaps adding in a few more seconds' leeway to accommodate any changes to your script you may make subsequently.

figure 13.5 narration sound levels: whether you're using the onboard microphone or an external one, keep an eye on the levels, using the software's level meter, to make sure that you are not too loud or too soft. Minor adjustments to the sound level can be made later.

Recording a narration

To record your voice-over you need to first ensure you've a pretty quiet environment. You don't want your carefully enunciated words peppered with the sound of doors slamming, passing traffic or any other background noise pollution. That noise pollution could also come from your computer itself. On a daily basis we pay scant regard to the whining of fans and the spinning of disc drives, yet even these lowly sounds could impinge on our recordings and distract from the, we hope, erudite text.

So how do we, on the most modest of budgets, achieve recording studio quality? The answer, of course, is we can't, but we can make the recording conditions as good as we might reasonably expect from a domestic environment.

First, make sure windows are closed. Conventional double-glazing very effective at reducing external sound that – unless you live near the threshold of a major airport runway – will contribute negligible interference. Next, make sure that when you're recording you are doing so in a quiet house. Banish all family members or put them on best – silent – behaviour. Remember that you don't need that long to make your recordings.

Try to avoid recording in a room with wooden floors and little in the way of upholstery. Laminate floors may be great for keeping down the dust, but acoustically they're a disaster. Carpets, curtains and soft furnishings together will deaden echoes to the point where – for your recordings at least – you'll be hard pressed to tell the results from a more professional set-up.

Avoiding computer noise

Computer noise can be a little more problematic. Laptops are usually no problem. Ensure that they are standing on some resilient material (not a hard table that can transmit and amplify any vibrations). Reducing the generally greater noise from desktops will need a little more thought. By nature they are more difficult to move around. And cloaking them in the computer world's version of a tea cosy may succeed in reducing noise but at the cost of cooking the processor as airflow is reduced.

The best solution in these cases is to put as much distance between you and the computer. Bear in mind that every time you double the distance the sound level will fall by a factor of four.

So, if you normally work one metre from your workstation, extending that to four metres will reduce the sound levels to one-sixteenth the original. Of course, at this distance, operating the keyboard and mouse may be a little problematic and, if you don't like the ideas of trailing wires, go for Bluetooth models that will have sufficient range and, when you're editing, give you a clutter-free desk.

Using a directional microphone will help, too. If your production needs a substantial amount of narration, a good microphone will be essential. There are models designed for the purpose at all grades and prices; you may even have invested in an accessory microphone for your camera that could be pressed into service in this secondary role. Whatever your choice, begin by auditioning the sound quality and learn to get the best from the microphone by varying your position and the distance from your mouth. Quality is paramount, not volume. Over-loud recordings can be corrected later; poor quality recordings can't.

The importance of a script

It's worth noting too that, although you may be very clear on what you want to say, nothing beats working from a carefully prepared script. Then you've no excuse for not being word perfect (although, let's be honest, not even the most seasoned of pros will get it spot on the first time through). Armed with a script you can also learn to pace yourself correctly. You can mark on it where you need to be when scene or shot changes occur.

Editing your soundtracks

If you've decided it so merits, your movie might well now boast an original soundtrack, background music, incidental music, sound effects and a commentary. Most likely it will include the original soundtrack and at least one other effect.

If you've already practised using transitional effects on your video – fading, crossfading and the like – you'll be pleased to know that audio editing involves very similar techniques. Audio tracks can be shown on their respective part of the timeline as a simple line, whose position represents the volume. Drag the line downward and the volume of that track is reduced, drag it upward and it gets louder.

Timeline audio editing

Increasing or decreasing the volume as a whole is something that we tend to do only occasionally where, for whatever reason, the level recorded was incorrect. We are more likely to want to alter the level in specific parts of the audio. Consider these cases:

- normally soft incidental music needs to be increased in volume at a crucial dramatic point
- background music needs to be reduced in volume – but not silenced – when a narrator starts to speak or another prominent sound needs to be heard
- audio and video need to be faded at the end of the scene or of the production.

By clicking on specific points on the audio track we can lock the levels and then drag the level to one side of the lock to its new level. In this way we can lock the level prior to an audio fade – when the sound level is reduced to zero – and then drag the level to the right of the lock to the baseline. You can apply a similar process – in reverse – to fade the sound level in.

figure 13.6 altering the sound level: the sound levels can be adjusted by dragging either the whole sound level down or by selecting elements and adjusting only those.

It is also possible to fade in laughter and applause. This is especially useful when you have a long sound effect but only need a brief sound. Fading in and then fading out the effect sounds remarkably authentic, though you should, of course, listen carefully to any modifications that you may have made.

Of course, as you are making adjustments to the audio you can monitor the video in the main window to ensure that your adjustments are being made with critical accuracy.

figure 13.7 audio fade: by adjusting the levels so that they rise from or fall to zero we can create an audio fade-in, or audio fade-out.

Linking sound to action: the back time

Here's a neat little audio trick that the professional sound editors use all the time. Incidental music is designed to emphasize a situation: think of that pensive, stalking music from horror films as an example. It builds and builds until there's an explosive climax at the precise moment something dramatic happens on screen. How do you get the sound in perfect synchronization with the action on the screen? It's a process that harks back to the heyday of the film-based movie and is called 'back timing'.

Audio editors would make careful note of the duration of the music between its start and the climax. They would then count backward from the point on the film where that climax had to fall and lay down the audio track from that point. Not technically difficult, but a whole lot easier today using digital video editing techniques.

You can drag your soundtrack to find the precise position for your cinematic climax either by trial and error (which, though not rigorous, can be reasonably fast and effective) or by changing the display of the audio track. Most video editing applications let you display the audio track as a waveform rather than a simple line. As a waveform you can see the loud – and the loudest – passages in the music and then lining that up with the appropriate frame of the video becomes a cinch.

figure 13.8 in waveform mode it becomes simple to identify the audio climax and align it with the corresponding video. Here the sound is being synchronized with girls jumping on a trampoline.

Camouflaging cuts and eliminating extraneous noises

If you've kept your original soundtrack as the main – or perhaps only – audio, you might be disappointed with some of the results. Cuts between scenes don't just cause visual change, they also produce audio changes. Even if there is only a modest change in camera position between two adjacent shots you'll find an obvious change in the audio track. Professionals overcome this by recording a wild track – a special sound track of the ambient noise that can be used to even out changes in the actual ambient sounds. We won't – for the most part – have the luxury of being able to do likewise, but we can make a subtle change to the soundtrack to overcome the most obvious of audio changes.

By fading the sound slightly before and after a cut – just by a modest amount (say 20 per cent) for a fraction of a second, the harsh audio cut can be suppressed and become virtually unnoticeable.

Likewise you can 'dip' the soundtrack when a loud extraneous noise appears. A sudden and unexpected noise – for example a dog barking or a car horn sounding – can be disconcerting for your audience. Not only did they not expect it, but they will be bemused. Was it part of the action or not? By carefully dipping the volume (say by 30 per cent) at the precise point of the intrusive noise you won't remove the sound entirely, but you will reduce the prominence to a point where the audience will consider it irrelevant.

figure 13.9 dipping the sound: the itinerant bark of a dog isn't easy to remove, but can be reduced in prominence by dipping the sound level just momentarily.

Level and emphasis

Because we have such control over the levels of sound it can be tempting to use them – and vary the sound levels (almost) continuously. This can be unsettling for the audience. A good analogy would be the way in which sound levels of TV commercials are often significantly higher – that is, louder – than that of the programming which they interrupt. Nothing antagonizes an audience faster! Try to keep a few ground rules when it comes to editing and manipulating your sound levels. In particular:

- background music should never be louder than a narration, conversation or 'actual' sound
- narration and voice-overs should be at a constant level throughout
- the speed and amount of audio fades should also be constant throughout a production
- no individual sound, or sound effect, should be especially loud – the drama comes from the sound itself rather than the discomfort of the audience!

Summary

You should now be aware of the importance of the soundtrack of your production. It really is simple to add additional sounds – of any type – but the skill comes in choosing the right material, whether that material is background music, incidental or a sound effect.

Narrations – should your production demand one – are best applied post editing rather than at the time of recording.

Editing your sound is both as easy as editing video and as important. You can spend a long time editing your video clips and scenes and get great visuals, but without spending a commensurate amount of time ensuring the audio is up to the mark, your production will be compromised.

digitizing old film and movies

In this chapter you will learn:
- how to turn dusty old home video movies into digital movies
- about the kit required and how we can get the best from it
- how to edit old movies and write them to DVDs.

It might seem at first a little incongruous to spend time in a book about digital movie making discussing analogue video. Many of us have spent formative years with a video camera in the days before digital technology and all the blessings that has conferred upon us. So in this chapter we'll examine how we can bring those recordings in to the digital age – in some cases improving on the original.

The process we'll use is also valid for other analogue originals. For example, those with a longer background in movie making may have cine film that has, at some point, been transferred to analogue video tape. It is even valid for creating digital video from live analogue television and, subject to the usual copyright conditions, any old videotape recordings. Best of all, with the old material in a digital format we are free to produce copies on DVD, for the web or even to enjoy on an iPod.

Overview

To import analogue video we need to replace our digital source – that is, our digital video camera – with a player of our analogue video material and a digitizer, a device we touched on in Chapter 04. This unit performs the conversion of the analogue signal to a digital one.

The player of the analogue material will depend upon what that source material is. In most cases it will be a VHS VCR, but might equally be an analogue (perhaps Video 8, Hi8 or VHS-C) camcorder or a videotape recorder of another vintage. The ability to play our cherished media is the only requirement.

Once this media has been digitized the signal imported to our computer is identical to that we would expect from a digital video camera and subsequently we can edit and process in exactly the same way, albeit with a couple of caveats that we will explore later.

Getting the best from a videotape

Before we begin downloading our family archives we need to make sure that we will get the best possible results.

Whatever the analogue source, it is going to be of a quality – in picture and probably audio terms too – lower than that which we would expect from a digital source. The nature of analogue

recording and playback is such that the definition will be lower and image precision, too, will be less. Colours bleed (spread into surrounding areas) and sharp edges tend to become soft.

Sadly, this is the norm for analogue video. Should your VCR be a little past its prime, the picture – literally – can get worse. Worn playback heads, dust and dirt, and a well-used videotape can all conspire to deliver picture quality that is, at best, average.

Reduce image degradation by taking a few precautions. Begin by running a head cleaner through your VCR to clean away the worst of the dust and dirt that can accumulate with time. Make sure that you use a recommended cleaning tape and follow the instructions provided with it.

figure 14.1 head cleaning: a VCR – especially one that has been dormant for some time – may benefit from a good cleaning using a head cleaning cassette.

Next fast forward and then rewind all the tapes that you propose to digitize. This will ensure that when you come to play the tape for copying it's going to flow freely. Check – by viewing

on a TV – that the tape is playing well. You may need to adjust the VCR's settings to get the best out of old tapes (and particularly VHS tapes from the 1980s) when replaying them on machines that are of a more recent vintage. Settings like tracking may need to be tweaked. The instruction manual for your VCR (the one you put in a safe place so many years ago) will advise you on making this adjustment. Plate 12 shows a tracking error.

You may need to be a little realistic about performance: if you haven't taken a look at your videos for some time and have become used to the quality of digital video and DVDs you may be a little disappointed. Remember that even when performing at their best, analogue video systems produce softer results than digital.

Connecting up

When you're satisfied with your VCR and tape it's time to connect the kit together. Here's how.

1 Take a look at the rear panel of the VCR to establish the connections. Most digitizers use RCA phono connectors (see page 213) for their inputs. Though some VCRs also feature these they are more likely to use a SCART connector. Phono connectors are usually coloured white for left channel sound, red for right and yellow for video. If you are using phono connectors, check that the connections are for outputs: some VCRs have phono connectors that are designed only for input (i.e. for copying a tape from a camcorder).

2 Connect your VCR to the digitizer. Use phono to phono cables if appropriate, otherwise a SCART to phono. If you don't have the right cable they are readily available at electrical and TV stores.

Camcorders sometimes have different connectors for outputting video. If you are connecting an analogue camcorder to the digitizer you will need to use the cable supplied with it (which normally ends in phono connections).

3 Connect your digitizer to the computer. Depending on the model, this will connect using either the FireWire or USB2 inputs on the computer.

4 Start the software. Some digitizers come bundled with software designed for the device, others will work with any digital video editing software and are recognized by the software as if it were a camera.

Specialized connections

Super VHS, Super VHS-C and Hi8 – the so-called hi-band format – VCRs can deliver higher picture quality than their standard equivalents. To take advantage of this you'll need to use a special lead to connect the hi-band output of the VCR to the corresponding input of the digitizer. This does not replace the other connections: the hi-band connection (often called S Video) does not carry sound, so you will have to ensure that the audio connection is made using the methods outlined above (it's sometimes worth disconnecting the phono video connection to ensure that the digitizer is forced to use the higher-quality input).

Downloading video

We mentioned earlier that an analogue VCR and digitizer act in the manner of a digital camera so far as your computer and software are concerned. There are a couple of differences, however.

The first is camera control. With your digital movie camera you can control the playback of the recordings from the software. That control is not possible when using an external VCR. Instead you'll need to start the software's input – as for a digital video camera – but then start the replay of your analogue tape by pressing the 'play' button on the VCR. All being well the output from the VCR will appear in the monitor window of the software.

If you don't see anything you may need to restart the software – or even the computer – to make sure that the digitizer is recognized.

The second difference is scene splitting. You'll usually find that the digitized video is recorded as a single scene rather than being split into separate clips. You'll have to do the splitting manually once the download is complete.

Downloading is an automatic process so there's no need to monitor every second though, on your first attempt, it's worth keeping an eye on the process. Some software has a limit on how much video can be downloaded as a single clip and you need to check that if this limit is reached the following video is automatically stored as a second clip.

Downloading problems

Once you've reached the end of the tape give the recording a quick review to make sure that it's been successful and that there have been no problems. Digitizers and digital editing software are designed to work with a good quality signal. Low quality analogue video – perhaps due to tape damage and visible as streaks and slurring on the picture – can baffle the system. In these situations the software will bale out and just present you with a blue screen as you record and a blank screen on the recording.

Sometimes you can repeat the recording with some success but often it's better to discard these passages – even if a repeat recording is more successful it won't look good.

Mobile solution

If you've a laptop computer you can work in exactly the same way as we have described here. For a more portable solution – one that you can take to the video rather than vice versa – you can even purchase a digitizer that will plug into your laptop's PC card slot. This is an ideal solution if your laptop boasts neither a FireWire nor a USB2 connector.

Editing your newly digitized video

In terms of editing, the video clips (assuming you've cut your video into clips) can be handled – in a creative editing sense – in exactly the same way as digital video, but first we can use our digital editing application to improve our newly digitized footage.

Each programme will have slightly different methods for improving analogue video clips (by which we mean video clips that began life as an analogue recording), but no matter what the method, you can be assured of results that look far better than the original.

In Ulead VideoStudio for example, you can make use of the DeNoiser and Colour Balance filters, found in the Video Filters section. The DeNoiser filter will remove the spurious analogue noise which reduced contrast and definition in your movie, while the colour balance can be used to give both a more neutral colour to the scenes and, if necessary (which it usually is), pep up the colour saturation a little.

IMovie provides similar commands for enriching the colour and neutralizing the colour casts, as does Premiere Elements.

You may also need to trim your video frames to cut away wavy edges. Analogue video is prone to lateral stability problems. What this essentially means is that each frame may not be perfectly aligned at the left of the frame and instead you'll have a wavy edge (see Plate 13). Untidy to look at, it can get more pronounced according to the amount of wear on the video tape. A well-worn tape or a copy of a VHS tape made to another VHS tape will be particularly bad.

If this is a particular problem on your old tapes, you can purchase timebase correctors that can ease the problem, but at a cost. Alternatively you can crop your frames – if your video editing software will allow – to trim away the rough edges.

Saving your digitized movies

Once you've corrected the shortcomings in your video material and performed your edits you'll need to save the fruits of your labours. Bear in mind that you now have a copy of your source material that will be less prone to degradation over the years. It's a good idea to keep a master copy of your video that you can – sooner or later – convert to any format you choose. Depending how long your video is you may be able to store this on DVD (as a data file) or on an external hard disc drive.

For day-to-day use you can master a playable DVD as you would from any other digital video. At this point you can further enhance the original by incorporating chapters, animated menus and all the other accoutrements which we have come to expect from DVDs. Package the DVD in an appropriate case – complete with a case insert produced using an image editing or desktop publishing application.

One-box solutions

Got a huge library of old videos that you need to convert? Investing in an application such as Pinnacle's Studio 500 could be a good move. Applications like this provide a dedicated digitizer and all the software needed to download, edit and create DVDs.

These one-box solutions are great for those of us who want a simple way of producing DVDs without necessarily going

through all the intermediate steps. In Studio 500 you can go one step further and use Instant Transfer to produce DVDs directly from your original video material.

Summary

- Digitizing your old movies is a simple process and can breathe new life into your old footage.
- You'll need a digitizer to convert your original video but can generally use your existing video editing software.
- You can use your editing skills to enliven your old movies by adding digital transitions, effects and titles – and remove those old titles and effects that look distinctly dated now!
- If you have a large number of tapes to convert take a look at some of the one-box solutions and instant DVD productions if you want results fast.
- Take care when digitizing to keep an original copy of the digitized material – not just a copy saved to DVD (as this will be compressed and not match the quality of the original).
- You can bypass the computer entirely if you have a combined VHS VCR/DVD recorder, but you won't be able to enhance the recording in any way. This method is okay – but no more – for quick back-ups.

15

finishing and publishing your movie

In this chapter you will learn:
- what to do when you have successfully completed all your editing
- how to publish your movie for delivery across a wide range of media and devices
- about automated movie production.

After all the shooting, all the editing and all the heartache we're into the final leg of our journey. Our movie will be, to all intents and purposes, complete. So, what now? Well, the movie may be complete, but it's not exactly in a form that we can share conveniently with our family, friends or, if our ambitions are a little wider, the world. It still exists as a project, with all our modifications and additions embedded. To share it we need to produce versions suitable to be enjoyed by our potential audience. That will include (in no particular order):

- posting on the internet
- computer-readable media
- burning to DVD or video CD
- a high definition disc format
- delivering on portable devices – mobile phones, media players and iPods.

We could even create, for those not yet blessed with (or sold on the benefits of DVD) VHS video tape. First though, as a safety feature, we need to create a back-up of our movie project.

Creating a master copy

Sitting on a computer hard disc is not an ideal location for your movie. Not only is it inconvenient for sharing it's also taking up a large swathe of valuable space and is vulnerable to accidental damage – or even deletion! Our first task, then, must be to make a perfect copy – a master copy – that we can archive and keep safe for any future work that we may want to do.

Future work? You'll find that, as your skills and abilities progress as you direct and produce more and more movies, you'll identify elements in what will now be your earlier movies which can be better edited, particularly as, with experience, your editing skills will improve. To ensure you can do this you need to make sure that you have – not a copy of any videotape or DVD you produce – but a copy of the project itself.

Saving to a disc

We've a couple of alternatives for saving our movie project. Often the most convenient is saving it to a DVD disc. This is a useful way of saving all small- or medium-sized movie projects. Your video-editing software will take care of the process for you. Using commands such as 'back-up project' your project

will be written to DVD. Copying your movie project to a DVD is not quite the same as producing a DVD movie. DVD movies are designed to be played on DVD players as well as computers and are encoded in a special way (which we'll explore in more detail later). A DVD back-up of a project is merely using the large capacity of DVDs as a convenient way to store a large amount of data.

Saving to tape

What if your project is larger than the capacity of a DVD? Some software applications will allow you to make a back-up copy that spans several CDs (in much the same way that back-up software for your important data can make a copy of that data over several discs). If you've a high-capacity drive – such as those that are becoming increasingly common, Blu Ray or HD DVD – then you can use that in exactly the same way.

However, there is a simple alternative that can be used on any computer, even one that does not have a disc drive that allows writing to DVD. Copy the project back to your camcorder. Drop in a new tape and export.

When you export to tape you can often choose to add some seconds of black screen to the start and end of the recording and also wait a set number of seconds for the camera to get ready. Most tape-based camcorders require a few seconds to get ready to record: winding and threading the tape and setting the record heads. Some cameras – and some applications – will require you to start the camera manually.

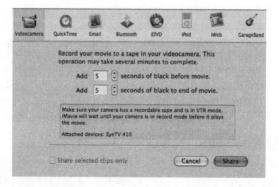

figure 15.1 exporting dialogue: here you can add some black screen before and after the movie. iMovie uses the rather confusing term 'Share' for exporting on this dialogue.

How long does the process take? It takes exactly the same as the duration of your video. As it's an automatic process you can sit back or head off for a cup of coffee.

Whatever method you use you should treat your copy with care. Ensure your DVDs or Blu Ray discs are properly stored. If you've written to a DV tape move the anti-record button to the 'on' position – label accordingly and file away.

Publishing your movie masterpiece

Okay we've got our movie finished and saved a copy – or two – of the project. Now we can set about publishing it. The movie, as it stands, is of very high quality, offering technical quality in video and audio terms, which is better than we would expect from a commercial DVD. The trouble is, that quality comes at a cost and the cost is filesize. As we've noted earlier, an hour of DV takes up around 12GB of disc space. That's enough to fill three single layer DVDs! So to share we're going to have to compress our video to make it more manageable to deliver. Let's take a look in turn at the most popular ways of publishing our movie: on DVD, to the internet and in a form that can be replayed on portable media.

DVD publishing

Publishing to DVD is the optimum solution. It offers the best quality (for standard definition material at least) and the media – blank DVDs – are readily available and cheap. DVD is also remarkable – from the consumer perspective – in that players are widely available and cheap.

To put a large amount of high quality video onto a DVD we need to convert it into the standard format – or 'native' format – of the DVD. This is the standard format MPEG-2 which produces a much more compact video file than the original DV but which sacrifices very little in the way of quality. In fact, because DVD players, as a rule, require the video to be encoded in MPEG-2 no matter what, even if we have a short video (one that might easily be copied to DVD) it still needs to be converted.

There are many applications available for converting DV to MPEG-2 but it's better to use proprietary DVD authoring applications. These don't just convert the video they also help us

build and structure our DVD. This will lead to a DVD resplendent with titles, menus and navigational tools, just like commercially produced ones.

The stages in producing a DVD are

- setting chapter marks
- designing the interface and the navigations
- encoding
- burning.

Setting the chapter marks

This is the process where we determine where we want the chapters in the DVD – those points that we can navigate to via the on-screen menus or using the forward and back buttons. Chaptering is one of the 'killer features' of the DVD that has helped make them so successful. They make it so much easier to navigate a movie than the rather hit and miss (and slow) way of navigating video tape recordings.

We can set the chapter marks in some, but not all, video editing applications (including iMovie). However, all DVD authoring software will let us do so. In either case the process is the same: identify the point for a chapter break, add a break and customize. It makes good sense to add a break at a logical point – if you regard your movie as a novel then the DVD chapter marks should correspond to the start of chapters or sections.

There's generally no limit to the number of chapters that you can add, but bear in mind that the more chapters you add, the more encoding that needs to take place – and that can add considerably to the time required to ultimately produce your disc.

It also makes good sense to give your chapter marks a meaningful name: this is the name that will appear with your on-screen menus.

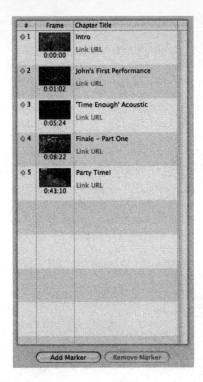

figure 15.2 chapter marks.

Designing the interface and navigations

Every commercial DVD has an interface with its own look and
feel, often designed to excite the viewer before the feature itself
begins. Here you'll have a title screen and, at the very least, the
option to click on a button to play the movie or select a scene
(for which, read 'select a chapter'). Most discs will also have
options to select extras – director's commentary, still images
from the film, trailers, alternative endings – and sometimes
hidden features.

Our DVD authoring software provides the tools to create our
own unique look and feel and helps design navigational aids –
buttons for example – to help viewers best enjoy our
production.

Fortunately for us – and particularly those of us whose graphic design skills may not be particularly sharp – the authoring software provides a range of templates that we can use for the basis or our interface (Plate 14). Sometimes all we need to do to personalize these is to change the titles or colour scheme, but some allow us to drag in video clips from the movie to produce animated menus – those where the video plays in the background or on buttons. You'll also see that if you click on the 'Select Scene' button you'll see all your chapters. Depending on the template you use you can display a clip from each chapter for each chapter selection button as a visual cue.

Editing tools let you customize your template at will. For example, you can change font types and colour, button shapes and position – even add a music file to play background music when the menus are on-screen (Plate 15).

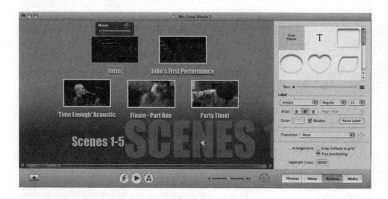

figure 15.3 template editing tools: chapters – and their titles – will appear on your template in a default format, but you can continue to customize, changing the positions of thumbnails, or the video showing, along with fonts and colours.

Have you noticed that some DVDs in your collection play out a short piece of introductory video before the menus appear? You can do this most easily by displaying your DVD project, not as a set of screen templates, but in map view. In map view you see a diagrammatic representation of your DVD project which illustrates the way different menus link together. In this view you can drag video clips and drop them on the screen thumbnails. Look at Plate 16, which gives you an overview of the links between menus and scenes.

Encoding and burning the disc

We can lump these two stages together because disc burning normally follows on automatically from encoding. When we press the 'Create DVD' or 'Burn DVD' button we set in progress the video compression routine. This can be tweaked to get the best combination of compression and quality.

A single layer DVD can hold two hours of standard definition video – or sometimes more – but the more video you try to cram on the more the quality will be compromised. If your project lasts under an hour (and by project duration here we mean that of the movie and, if you've added them, the animated menus) you'll be able to encode to a higher quality than a project that exceeds this time. If your movie itself lasts an hour you might want to provide more simple menus to allow encoding of the movie itself at the highest quality.

Encoding at high quality does take longer – even though the video itself is shorter – and we can be talking seriously long times here. Many hours is not uncommon (though your computer's processing speed has a significant bearing on the process). Keep an eye on the progress bar displayed and you can get an approximation of the time taken, and the time left.

Processing generally happens behind the scenes – so you don't have to wait for the encoding to complete before doing anything else on your computer. Whilst encoding is in process, you'll be able to get on with most other tasks on your computer.

At the end of the encoding your disc will then be burned. This is a much swifter process, taking only a few minutes. Want more than one copy? Make sure you follow the on-screen directions for producing additional discs.

Compatibility

The first time you create a DVD on your computer try the resulting disc out on your DVD player – and those of friends and family if you can. Use this as a check to ensure that your encoding settings are okay. Though the DVD disc format is very tightly defined and described there are occasionally compatibility problems – particularly when you try to play your DVD on older DVD players.

'Play from beginning' or 'Last played'?

You may have noticed when you insert a DVD that you've already played in your DVD player, the player will ask if you want to play the disc from the start or from the position you finished watching. This is useful when your viewing is interrupted. How do you add this feature to your recording? This is actually a feature of the DVD player, so you can't! Players' memories can identify discs inserted and the point to which they were last played.

Creating different disc types

Applications such as Roxio's Easy Media Creator (Windows) and Toast (Mac) can help create alternate disc formats including:

Video CD This uses standard CD-R discs to record an hour of VHS-quality video (using the poorer MPEG-1 compression rather than MPEG-2). The discs are compatible with Video CD players and some DVD players. Discs can also be played back on most computers.

Super Video CD This records 30 minutes of DVD-quality video (MPEG-2) on a DVD. Discs are compatible with a limited number of DVD players, but can be played back on virtually all computers.

DivX This uses a more recent compression type, MPEG-4 to compress even more high-quality video onto a CD. DivX compatible DVD players are required for playback.

Both DVD authoring software and media creation software will also write high definition material to disc, in the original form or reduced to standard definition. Upgrades to most of the packages will also write to the newly emerging successors to the DVD, Blu Ray and HD DVD, which are ostensibly similar to DVDs but offer much higher recording capacities. This makes both Blu Ray and HD DVD suitable for recording high definition video, but does require that any intended recipients have the means to replay such discs.

Internet delivery

The days of small, postage stamp-sized video delivered over the internet are long gone. Advances in compression routines make

it possible to deliver high-quality video to desktops around the world.

You can produce a movie suitable for internet use by exporting from your video editing software. You'll find your video editing software application will give you several options including exporting to email, internet, and internet streaming. They differ only in quality.

Email video is designed to be very compact: not only is the video itself small, but the number of frames per second is dramatically reduced from the normal 30 or 25 down to 10 or so. Sound, too, is heavily compressed. Rather than the CD quality sound of your original video, you'll have single channel, mono sound, heavily (and very audibly) compressed. This is to ensure that the video file is sufficiently small to add as an attachment to any email. You'll still need to check the overall size – though your file will be heavily compressed, if the movie is particularly long it might well exceed the size of attachment that you can send, or your intended recipients can receive – often 10MB.

Internet video (web video) is much more respectable in quality terms. You'll have a larger video size (with a resolution of at least 320 x 240 pixels (that equates to around one quarter the resolution of standard television pictures) and reasonably good quality stereo sound. File sizes are larger and this can require something of a wait while the video file downloads to the recipient's computer.

Internet streaming (web streaming) offers even better quality. Streamed video is video that can begin playing before it is totally downloaded – a great boon over standard video. This overcomes the need to wait for the download of a large file and allows the higher quality as absolute file size is not so critical.

Media players

If you've watched video on the web, whether downloaded or streamed, you'll have noticed that in most cases (that is, all but a few proprietary videos) to view internet video you need a media player. Consider this as a 'virtual VCR' – a software application that can be act as an interface between the incoming (or downloaded) video file and your computer desktop.

There are three commonly used ones – **Quicktime**, Windows Media Player and Real One player. Platform jingoism means that you'll find Quicktime is the default media player on Macs and

Windows Media Player on Windows PCs but all the media players are available for both platforms as free downloads. There are differences between them, performance-wise but they tend to be slight. You can generally export your movie in a format that can be recognized – or is optimized – for any of these.

Sharing internet video

When you've published your movie in an internet-savvy form, how do you make it available for others to download? You'll need to publish it somewhere on the internet. That 'somewhere' might be your own website or a dedicated video publishing website such as YouTube.

figure 15.4 web page creation software is now remarkably simple to use.

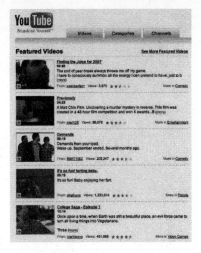

figure 15.5 video sharing sites are ideal for publishing your video.

Publishing to iPods, PSPs and media players

The iPod has been, like DVD, one of those major success stories of consumer electronics, quickly establishing itself in an otherwise unfilled niche. The white earphones are now de rigeur for commuters and leisure travellers alike. More than a mere music player, the iPod is now firmly established as a means of delivering video – everything from movies through episodes of TV programmes to video podcasts.

You'll probably not be surprised to know that you can also produce your movies to enjoy not only on iPods but other portable media players including that other iconic product, the Playstation Portable (PSP).

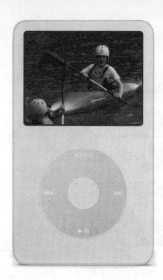

figure 15.6 iPod video: creating iPod compatible video is simple using Quicktime or any one of the many specially designed applications.

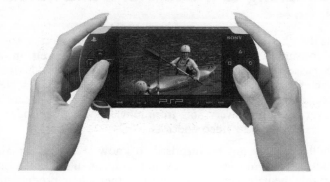

figure 15.7 Playstation Portable (PSP): with a larger screen than the original iPod, the PSP is a great way to watch movies on the go.

Production – from an original video – for an iPod is pretty simple. You need to export your video to iPod format, either using an option on your video editing software or, if your software doesn't yet have the option, using one of many cheap

utilities that have appeared for the purpose. The most straightforward way is to invest in Apple's Quicktime Pro and use the Export to iPod option there. Quicktime Pro is available for Mac and Windows computers as an online download. Here's how to do it – and bear in mind that the process is pretty much the same when using other, similar utilities.

1 Open Quicktime Pro and choose 'Open File ...' from the File menu.
2 Navigate to, and select the video file that you want to copy to an iPod.
3 Select 'Export ...' from the File menu.
4 Select 'Movie to iPod' from the export drop down menu and wait for the movie to be converted to the iPod-compatible format. The converted movie will appear on your desktop or in your Documents folder. The file will have the extension .m4v (see Figure 15.8)

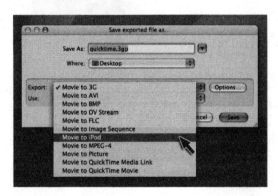

figure 15.8 export iPod.

5 When complete, start iTunes on your computer.
6 Drag the new converted movie file into your iTunes library and drop there (see Figure 15.9).
7 Synchronize your iPod with the computer to download.

figure 15.9 iTunes movies.

Depending on the size of your movie, you can treat it as any other internet-deliverable movie and make it available on a website for others to download and play on their iPods.

Because video podcasting and delivering movies via iPods is still a developing technology, make sure that you get the latest updates of Quicktime and iTunes to take advantage of any upgrades and updates, particularly with regard to video image size and compression.

For other devices you can use a different-but-similar exporting option, 'Export to MPEG-4'. Different-but-similar? MPEG-4 is essentially the same format used by iPods but selecting MPEG-4 produces a more generic file type that can be used in any media player that supports the very compact files that MPEG-4 produces.

Applications such as PSP Movie Creator (and its freeware sibling PSP Video Express) will produce movies that can be replayed on a PSP. The finished, converted movie can be downloaded to the PSP's memory stick. Unlike iPods which boast increasingly large hard disc drives for storing music and video, PSPs are restricted to the size of memory stick that can be

inserted. Rather than storing movies on your device, for the PSP you'll probably be better served by storing your video creations on your computer to be downloaded when required. Tools such as PSP Video Manager are ideal for managing and uploading videos to your PSP.

figure 15.10 PSP Movie Creator's interface makes it easy to convert movies for playing on PSPs.

figure 15.11 PSP Video Manager is a useful tool for managing your MPEG-4-converted movies.

By virtue of their popularity the iPod and PSP are well supported in terms of conversion utilities but there are many more portable media players around – some with much larger screens. Virtually all use the MPEG-4 standard for video and often come with their own software for video production.

figure 15.12 portable media players are a great way for you – or others – to enjoy your productions when on the move.

Is that it? No, if you pay close attention to the Export menus in the conversion utilities you'll see that you can also export your movie to other devices – including mobile phones.

There's been much debate about video on mobile phones and even iPods. Detractors cite the screen sizes of these devices being too small to be credible. However, the market has given them a vote of confidence. Perhaps a modest phone screen is not the place for premiering your latest two-hour blockbuster, but as a repository for your cherished memories – that child's birthday or anniversary bash – they are ideal.

What of videotape?

Though DVDs and other disc formats have displaced VHS video from its once-supreme position, you will still find that a few members of your potential audience will need to have a videotape copy. How do you oblige?

There are two ways, depending on your hardware. The best way is to copy – or rather export – your finished movie via an analogue to digital converter straight to your video recorder. This is the same device we employ in Chapter 14 to digitize analogue video sources, though this time we're using the electronics in reverse. The FireWire connector is now delivering a digital signal to the converter. After producing an analogue signal we can tap in via the analogue outputs and feed the signal into our video.

The analogue outputs normally comprise three RCA connectors: one for each of the left and right audio channels and one for the video signal. These need to be connected to the corresponding inputs of the video recorder. You'll normally achieve this via an RCA to Scart cable (readily available at electronics stores) or, if your video recorder is so equipped, using RCA to RCA connecting cables. A Scart–RCA adaptor is a useful – and cheap – way of ensuring total compatibility.

figure 15.13 a Scart–RCA connector lets you connect a Scart-equipped video recorder with the output of the A to D converter, using RCA cables. This one also has an S Video connector allowing you to connect the high quality video output from the converter to the video.

figure 15.14 RCA cables are easily recognized by their simple, single-pin structure.

What if you don't have an A to D converter? Don't worry. The second method takes advantage of the analogue output from your digital video camera. Designed for direct playback through a television, you can feed the output of your camera to the inputs of your video recorder instead. You can feed your video signal, via FireWire, to the camera first, taking advantage of the two-way communications of virtually all FireWire connectors on digital video cameras.

16

top tips for successful movies

In this chapter you will learn:
- some top tips for successfully producing popular movie types
- about some of the essential shots required when tackling different subjects
- some tips from pros for making your movie a success.

If you've read – and practised – everything we've detailed to this point you'll have amassed quite a few new skills. You'll be primed to head off with your camera and get some great shots ready for editing into some magnificent movies! To help you on your way we have gathered together some top tips from accomplished moviemakers that will point you in the right direction when you set out to create your movies. No matter what movie you are shooting – or editing – you'll be using the same fundamental skills, even though different movie types – or genres – have their own special approaches.

Detailed throughout this chapter are some great tips for ensuring that, whatever movie you choose or are called upon to make, you'll get great results. What video and movie types are we examining? Here's a summary. They've been ranked – roughly – in order of popularity:

- wedding
- holiday
- travel
- birthdays and parties
- music videos
- stage shows and performances
- sports
- instructional.

Top tips for wedding videos

1 Do your homework. Be aware of the structure of the service – especially if it is a faith with which you are not familiar.

2 Visit the location in advance so you can establish the best shooting positions. Discuss with staff or celebrants what can and can't be done. Some people will, if they are not entirely familiar or comfortable with the proceedings, sit in on another service to get the lie of the land.

3 Draw up a shooting script for the day. This needs to be rigorous. Discuss with the couple how they would like to have the video shot. Also ask them what they want shot. The bride preparing at home? The groom the night before? You want to shoot what the couple want but may need to suggest ideas that they may not have considered.

4 Never use new kit for a wedding. You need to be entirely comfortable with your equipment.

5 Check out the sound quality of your kit and the venue. For the best sound you might be able to place microphones in the hall, otherwise ensure that your camera's microphone (built-in or accessory) will give the best results.

6 Check out all your kit before leaving. Ensure that you've packed enough tape, blank discs (as appropriate) and batteries – including sufficient for contingencies.

7 Remember to shoot establishing shots and cutaways. If you end up shooting the service as one long continuous shot (criminally boring for the audience!), the cutaways will help break up the shot and help if you need to trim out any sections.

8 Avoid posed shots. That's what the stills photographer is there for. Shoot people arriving at the church at length – you don't want to miss the bride's mother!

9 Shoot long, edit short. Keep the camera going throughout the service, but don't be afraid to trim away any sections that are superfluous. A few seconds of guests waiting in the church, for example, are okay; five minutes not!

10 Create a slideshow of images shot by guests at the wedding for the final DVD or tape. Think of this as the 'extra feature' on the DVD – but it's also a great way to ensure that you've got a shot of every guest, even those who may have escaped your video camera through design or otherwise.

Don't commit to shooting the official wedding video if you've never shot one before. Practice – as many times as you can – by shooting informally at other weddings to which you might have been invited. Even seasoned pros can get butterflies over wedding videos: like stage performances you can't cry 'cut' and ask them to perform the scene again.

What if your camera fails? It can happen and often at the most inappropriate time. Pro photographers will have a back-up camera just in case. If you're taking the official video and you are being paid, you need to ensure that you've a back-up plan too!

Top tips for holiday videos

1 Make your video tell a story – when edited it'll look best (and look complete) if it has a beginning, middle and end.

2 Shoot the whole event – including departure and travelling. These are part of the holiday, too.

3 Remember you're shooting a holiday video and not a travelogue. It's a personal trip not a sterile production. Shots of your friends or family interacting with people and places at your destination are crucial.

4 Shoot loads – you can edit down later but you can't go back and re-shoot extra footage if you've been meagre the first time around.

5 Don't forget to shoot yourself. Or, get someone to shoot you. Otherwise, in years to come the family will be disappointed not to have a record of you on the video, too. Resort to the self-timer or auto shooting if you'd like a full-family shot.

6 Shoot details and wide. Standing in awe at your holiday destination, you almost instinctively shoot wide sweeping panoramas. By all means do so, but don't forget the details that also make your destination so memorable – unique street furniture and passing trams, for example.

7 Shoot location titles – these are preferable and more informal than titles produced later. That shot of a direction sign or entrance to a park and the like make ideal location titles.

8 Make the final video short and punchy. You may have shot several hours of material but when you review it, certain sections will stand out as 'must-haves', but an awful lot more will shout 'must go'.

9 Bear in mind the audience when editing: you and your close family – those who shared your holiday – will have memories of the trip that you'll want to include. A show for friends or extended family can – as discussed in the previous point – be more tightly edited. Why not call your longer version your 'Director's Cut'?

10 Think about security. There are always risks, but flashing an expensive-looking camera around in some areas can invite unwanted attention. Learn to be discrete where necessary.

Top tips for travel videos

1 Unlike a holiday movie, a travel video is not a personal story, it's a documentary. It needs to have a story, a script and, of course, a structure. An opener to the movie might show the location, how to get there and so on; the body of the movie will look at different aspects of the location (or locations).

2 Capture local colour. It's easy to concentrate on the landmarks and the large scale elements of the landscape but don't forget to shoot detail and local characters.

3 Be sensitive to your environment. In some places and cultures it is bad manners or considered rude to shoot in certain locations (churches for example) or shoot people on the street. If in doubt, ask first. You'll get better results from an accommodating local in any case!

4 Be very careful when shooting at or near locations that can be considered a security risk. Military installations must obviously be avoided, but in some countries civil airports, transport infrastructure and even road junctions are considered equally off-limits to camera users.

5 A great way to close a movie is with the sun going down. Okay, so it's a cliché, but it's one that works!

Top tips for birthdays and parties

1 Make a day of it. Children's birthdays begin when the child wakes expectantly, so make sure you shoot those magical bits, too.

2 Set a theme. Is the child's birthday themed in some way? Pirates, fairies or cartoon characters? Use the theme to set a look for the video too, with titles, any background music and incidental graphics in the same style.

3 Get down low. Shoot children's parties from the children's eye level and get in close. If they look at the camera, don't worry! Shooting from our eye level makes children look subordinate.

4 Get some shots of the birthday cards. Often a collection of cards and perhaps a close-up of a selected card makes for a great video title.

5 Shoot close-ups. Children's expressions at parties are a picture – literally – so again, make sure you get some close-up shots. They're great as stand-alone shots and as cutaways.

6 Go for multiple takes on the candles being blown out on the cake. This is one activity that you can shoot multiple times and the participants will be only too willing! Use different angles each time and different shot types.

7 Get the kids to shoot each other. Okay, so this one may depend on the age of the children, and you'll probably have to discard much of the footage, but you can get some truly memorable shots.

8 Go for the interview. A great way to wrap up the video is to interview – informally of course – the child (or indeed whomever the party was celebrating) and get some great soundbites. What did they enjoy best? What were their favourite memories? Comments become more precious as the years pass.

Top tips for great music videos

1 Even apparently ad hoc music videos need to be scripted – shooting on the fly just won't work.

2 Like a wedding video, meet with the subjects (in this case the singers or band) and see what their expectations are. What kind of video are they expecting and what can you deliver?

3 Get to know the location. You need to know which places are best to shoot from, how the lighting works and how you can get the best sound quality. Can you, for example, patch into the sound system at the venue?

4 If you need to, gather together additional sound equipment or lighting and demo them at the venue.

5 Sound is important for all video work, but is crucial for your music video.

6 Shoot key performers several times if you can. Useful for inter-cutting later.

7 Avoid clichés: Dutch tilts, fast cutting, absurd special effects have all been done to death and, rather than making your video individual, they will make your production one of the herd.

8 If you've a friend with a camera ask them to shoot with you. Ensure both cameras are configured identically at the start to make sure that there are no colour or contrast problems when (later) cutting between the two. You will have to make sure you sychronize the resultant footage when editing.

9 If using two cameras, have one concentrate on close-ups while the other does continuous general recording.

10 Shoot plenty of cutaways to help join scenes that might have been shot at different performances. A baying crowd, or over-the-shoulder shots of the band, make for great cutaways. Cutaways are also useful if you are trying to synchronize your video and audio soundtracks if you've used two cameras.

Top tips for videos of plays and performances

1 Plays, performances and concerts are structured with beginnings, middles and ends so it's important that your video reflects this.

2 If you plan to shoot a commercial performance make sure that you're not falling foul of any copyright issues: some venues and events strictly ban all recording equipment, others ban only stills cameras and audio recording.

3. Use the brochure or the front of the theatre (if it's a major production) as your title.

Top tips for great sports videos

1 Know your sport – sounds obvious but if you are shooting a sport about which you have little knowledge, you'll struggle to get the right angles, or even to know where to point the camera in the first place.

2 For team sports it's important to capture the interaction between members of the team; for individual sports you need to concentrate on the expressions of the sportsperson.

3 Get a good mix of the field (for field and team sports) and close-ups of participants. Long shots of a football field quickly become tiring.

4 Break the rules about camera movements. This is live action and you can only prejudge the movement of player and the ball to a point. Fast movements to catch up with the action will usually be acceptable. If not, they can be trimmed away later.

5 Ensure that you capture 'the moment'. That's the elusive moment in any sport when emotion and skill are at their peak. It's the winning shot – and the expression on the scorer's face. Or it's that elated look when a contestant realizes that they have the best time.

6 Keep the camera rolling – and edit out any bad handling or poor technique later. You can't risk a situation where you miss a crucial moment because the camera was switched off. However, your audience will accept a fast pan to – say – a goal mouth to capture the action there even if you miss the goal itself.

7 Games, too, have a structure. There's the start – when the teams come on to the pitch or the contestant prepares for action. Then there's the game itself and, as a close, any victory celebrations.

8 Shoot plenty of cutaway – we say this all the time, but they're just as important here. Shots of the crowds, the scoreboard or linesmen make great visual asides when you need to start trimming down your footage.

Top tips for instructional videos

1 Instructional videos need a precisely defined purpose that may be reflected in the title: 'How to make a scrapbook' or 'How to clean a car's fuel injection system'.

2 The video should be structured in a more formal way than most other video projects. It should set out the objectives in the introduction, meet those objectives in the main body and wrap up with a summary.

3 Whether you are instructing on a tabletop craft, producing a 'how-to' or teaching a sporting skill, you generally have more control over the environment than is normally the case. You can adjust the lighting, sound and camera positions (which should be tripod-based for most shots) until they are spot on.

4 Our earlier advice on restrained use of captions can be disregarded here; on-screen captions and bullet points can add value to your instructional video and provide a useful way to reinforce points and to recap.

5 Be mindful of the potential use of your instructional video. Most will be viewed on TV, but some may be more suitable for watching on a computer screen or a portable device. In the case of the latter, make sure that any captions or explanations work visually on a diminutive iPod screen as well as on larger displays.

Summary

You'll have gathered from this chapter that different types of movie need a different approach. If you favour one type of movie making this shouldn't preclude you from attempting another. Though professional movie makers do tend to become expert on one field, even they will be reasonably adept at others.

There's no doubt that the more you shoot – and the more that you edit – no matter what the subject, it will help you become a better movie maker!

If you've a special skill or indulge in unique activities, an instructional video (or DVD) can be a great seller. People much prefer to watch a DVD than read a manual so, whether it's parascending or car maintenance, you could be on to a nice little earner!

glossary

(Cross references are italicized.)

1080i
highest resolution form of high definition television (*HDTV*) using 1080 lines interlaced

1080p
highest resolution form of high definition television (*HDTV*) using 1080 lines *progressive scanned*: usually preferred over 1080 for its cinematic quality but requires more bandwidth

720p
lower resolution form of high definition television (*HDTV*) using 720 lines *progressive scanned*

Analogue
any value that is continuously varying (such as volume, or colour); in video terms any recording format or system that records continuously varying values. Compare this with *digital*, in which all variables are converted to a digital form (a numeric sequence of binary 0s and 1s) prior to recording

Aperture
the opening in a camera lens through which light can enter. An iris diaphragm adjusts the size of the aperture so that the optimum amount of light falls on the sensor according to the light levels in the scene

Artefact

a degradation in a video image due to the recording process. In analogue video degradation is generally a loss of contrast sharpness and colour fidelity; in digital video artefacts result from *compression* of the image and tend to manifest themselves as rectangular mosaic-like blocking of the image

Assemble edit

editing process where individual clips or scenes are recorded sequentially according to their position in the finished movie. Also called 'linear editing'

A to D conversion

analogue to digital conversion. A process in which an analogue signal (video recording, audio, television signal) is converted to digital so that it can be imported and subsequently manipulated on a computer. Finished digital recordings can be fed back through the converter to produce an analogue output signal where this might be required (such as producing a VHS video copy of a digital original). In this case the device is called a D to A converter

AVI

Audio Video Interleave. Digital video format devised by and extensively used by Microsoft, particularly in Windows applications

Banding

video artefact that causes smooth colour, tonal or brightness gradients to be represented by stepped transitions. Often occurs in areas such as sky due to too much image *compression*

Blu Ray

high definition successor to the *DVD* used especially for recording *high definition* movies

Blue screen

technique for combining actors (usually) with elements of a different scene (often computer generated) by superimposing the second scene over one colour in the first scene.

Originally actors performed in front of a blue screen (hence the name) though green is now the preferred colour for technical reasons. Sometimes known as Chromakey

Broadcast quality — any video programming that is deemed (sometimes rather arbitrarily) as equivalent to, or of sufficient quality to be, broadcast

Capture — the importing of digital video (or analogue video via an appropriate converter) into a *digital* video editing application

CCD — charge coupled device. The basis of the light sensitive chip inside most video cameras. Some cameras feature three chips, one sensitized for each of the primary colours red, blue and green

Chromakey see *Blue screen*

Chrominance — the colour component of a video signal. Combined with the *luminance* signal, the pair produce a complete image. See *component video*

Clip library — the collection of video clips imported into a video editing application and available for dragging to the *timeline*

Clip Shelf see *Clip library*

CMOS — complementary metal oxide semiconductor: an alternative light sensor to the CCD used (mainly) in lower price cameras

Codec — compressor/decompressor. A process for rapidly compressing and decompressing video. *DV*, *MPEG-1*, *MPEG-2* and *MPEG-4* are examples used with digital video systems

Component video — video system that uses separate channels and cabling for the *chrominance* (colour) and *luminance* (brightness) signals. Delivers a better picture quality than video signals using the composite video system where both signals are combined

Composite video see *Component video*

Compression
a technique for reducing the amount of data in a data file (video, audio or picture) in order to make it easier to store and transmit the data file. Certain compression techniques are known as *lossless* because they can compress a file and then rebuild the original signal without degradation; other techniques are called *lossy* because quality and detail is lost, often in proportion to the amount of compression applied

Compression rate
a measure of the degree of *compression*. DV video is compressed by 80 per cent (i.e. a compression ratio of 5:1), HDV somewhat more

Continuity
the flow of characters, plot and environmental elements in a video. Bad continuity would be illustrated by characters whose clothing or hairstyle varies sequentially (due to scenes being shot out of order) or unexplained changes to the storyline

Control-L
an analogue edit control system pioneered and championed by Sony for synchronized editing between an analogue camcorder and analogue video recorder. It is a variant of the Lanc system, both of which are now superseded by digital techniques

Cropping
in a video clip, the selection and saving of a section of the clip and the discarding of sections (generally at the start or end) deemed irrelevant. See also *playhead handles* and *trimming*

Crossfade
transitional effect between two scenes where one scene fades out as the other fades in. At the mid-point of the transition, both scenes are equally prominent

Cut

a simple transition (the default transition) where one scene or shot ends on one frame and the following scene begins on the next frame. Also a term used sometimes to describe the action of splitting a clip

D to A converter

digital to analogue converter. Hardware device (usually) designed to convert the digital output from a computer to an analogue signal. Often the same device as used for an *A to D conversion* but with the signal paths reversed

Data rate

the amount of data passing through a system (computer, camcorder recording system) for a given time period. In general, the higher the data rate the better the video quality. Also applies to audio files where higher data rates deliver better, more detailed audio

Digital

in general, electronic technology that generates, processes and saves any data in a form of binary code – 0s and 1s; in video, cameras and computers (or other processing equipment) that record video as digital signals and process them accordingly

Digital Betacam

digital version of the popular analogue broadcast standard video format Betacam (itself a professional evolution of the Betamax format)

Digital zoom

zoom found on most digital video cameras that produces very large zoom ratios (magnifications) by recording progressively smaller sections of the *CCD* and enlarging the image. At extreme zoom ratios the result is low resolution, poor imagery and hence their use is not generally recommended. *Optical zooms* – which preserve the full resolution of the CCD – are preferred

Digital-8	digital version of the once-popular Video 8 and Hi8 formats designed to use compatible tapes and some compatible hardware
Digitizer	a hardware unit (usually) designed to produce a digital output from an analogue input signal. See *A to D Conversion*
Dissolve	a transition effect where one scene blends with the next by the former appearing to dissolve away, leaving the following scene to continue playing
DV	digital video. The acronym for digital video in general but more specifically applied to the recording format and *Codec* used by many digital video cameras
DVB-S	digital video broadcast by satellite: the standard for digital television delivery by satellite used mainly in the UK, Europe and Australasia
DVB-T	digital video broadcasting – terrestrial. The standard for terrestrial digital television broadcasts in most of the world
DVC	digital video cassette: name for the original cassettes of tape used for DV recording
DVCAM	semi-professional version of DV that uses different compression techniques and a higher tape speed for better quality recordings
DVCPro	another variant of DV that is principally used by Panasonic. Tapes run 80 per cent faster and offer higher quality; often used for news gathering
DVD	digital versatile disc. Disc-based storage medium that supports several different formats including DVD video (as used for movie and video storage) DVD-R (recordable DVD)

DVD-ROM (data) and DVD-RAM (re-recordable). DVDs are also used in DVD video cameras, which use the MPEG-2 recording format

Field

one of two television images that are *interlaced* to produce a complete TV picture. In *standard definition PAL* televisions, each field is 312 lines and is displayed for 1/50 second. This delivers 25 full frames per second. In *NTSC* each frame is 256 lines and is displayed for just under 1/60 second

FireWire

name given by Apple to the standard *IEEE* 1394 interface and communications system. The standard connection used between DV camcorders and computers. It is a bi-directional link that allows data to be passed to and from computers

Generational loss, generation loss

the loss in quality resulting from copying a video tape from one recorder to another. This is substantial in the case of domestic analogue formats but negligible in the case of most digital formats

HD DVD

high definition DVD. Format touted as the successor to the DVD for the storage of larger amounts of data and high definition video. Like competing *Blu Ray*, it uses a blue/violet laser to record higher levels of data on a similar sized disc to a DVD

HDCAM

high definition version of *Digital Betacam*

HDCP

high-bandwidth digital copy protection. An anti-copying system built into *HDTV* systems to prevent piracy and copying of HD programming

HDMI

a connection used between high definition video and television components to transfer digital audio and video in uncompressed form, but

allowing anti-copying technologies such as *HDCP*. Most commonly found between an HD disc player or HD receiver and an HD compatible TV screen

HDTV high definition television. Television offering higher definition than *standard definition PAL* or *NTSC* standards. Uses 720 or 1080 horizontal lines of resolution to provide images up to four times as detailed as standard definition

HDV high definition DV: a format that uses DV tapes but records using MPEG-2 to offer high definition recording. HDV cameras are increasingly available in the consumer marketplace

Hi8 *high band* version of *Video 8*, a now superseded analogue camcorder format

High band analogue consumer video formats including SuperVHS (SVHS) and *Hi8* that uses *component video* for better picture quality and resolution compared with VHS and *Video 8* respectively

High definition, HD see *HDTV*

IEEE-1394 generic name for the communications/connections system branded *FireWire* by Apple and *iLink* by Sony

iLink see *IEEE-1394*

Interlaced the process of creating a television picture by combining two fields, one comprising all the even lines and one the odd. Used in *standard definition* TV and some variants of *HDTV*. See also *field*, compare with *progressive scanning*

Lanc see *Control-L*

Library see *Clip library*

Linear editing see *Assemble edit*

Lossless compression compression technique for digital files that can reconstitute the original media (video, audio or images) without loss of data

Lossy compression compression technique for digital files that discards selected parts of the data to achieve very small file sizes. Reconstituted files often show *artefacts* because of the 'missing' data

Luminance signal component of a video signal that carries the brightness information. A full video signal is produced when combined with the colour information in the *chrominance* signal

MicroMV digital video camera format that uses *MPEG-2 compression* to allow long recordings to be made on very small cassettes. Cameras are no longer in production

MiniDV video tape cassette (and format name) for consumer DV. Professional systems can use full-size DV cassettes

MiniDVD DVD-Video written to a CD-ROM disc. Discs can be played back on most DVD players but discs are limited in playing time (to around 20 minutes)

M-JPEG motion JPEG. A digital video compression system similar to the JPEG *lossy compression* system JPEG used in digital images

Motion blocking video *artefacts* that causes video images to break up into small rectangles due to the inability of an element in a digital video system (camera, encoder or player) to handle the *data rate* supplied to it

MOV, .MOV video format used for files in *Quicktime*

MPEG Motion Pictures Expert Group. Umbrella organization that determines and defines video compression standards

MPEG-1
a *compression* regime that produces digital video on a par in terms of quality with VHS video. Prone to *motion blocking* and other *artefacts* it forms the basis of the *VideoCD* format

MPEG-2
the compression regime used in DVD Video and some *high definition* television broadcasts. It is also used for *HDV*

MPEG-4
compression regime that produces compact files and is scaleable: it can be used to produce video at high definition, standard definition and even for small media players and portable devices. It is used extensively in smaller camcorders

Native editing
editing that is done in the format of the original media. It is often used to describe DV editing using computer-based digital video-editing software, although by a strict interpretation, DV editing is not native

NLE see *Non-linear editing*

Noise
image degradation normally due to electronic interference or from electronic effects. Tends to vary in extent depending on the size of the imaging sensor, the sensitivity of the sensor (higher sensitivity tends to produce more noise) and the light levels being recorded (noise is more prominent at low light levels)

Non-linear editing
editing system (such as that used by digital video editing applications) where a movie can be constructed from individual clips in any order

NTSC
National Television Standards Committee. US television standards body that has also given its name to the *standard definition* television format used in the Americas and Japan

Offline editing	editing conducted using copies of the original media. Depending on the copies, this can sometimes result in slightly poorer quality
Online editing	editing using the original media. Often necessary for delivering the best quality
Optical zoom	zoom lens found on digital cameras and digital video cameras (as well as conventional cameras) that uses changes in the optical configuration of lens elements to achieve the zooming action. This delivers an enlarged image (when zooming in) to the sensor. Unlike a *digital zoom* an optical zoom does not compromise image quality
PAL	phase alternation by line. The television standard (for standard definition broadcasts) used in the UK, most of Europe, South Africa and Australasia
Playhead	In digital video editing software the point on the *timeline* (and represented on the *scrubber bar*) of the currently displayed video image
Playhead handles	markers linked to the play head that can be dragged forwards and backwards along the *timeline* or *scrubber bar* to select a section of the video clip for saving (that is, *cropping*) or deleting (*trimming*)
Progressive scanning	video image scanning method (and subsequent reconstruction on a TV screen) where the image is built up as a single continuous scan rather than two *interlaced fields*. The result is a sharper image, but fast motion can be affected by *artefacts*. Often preferred by some TV directors because of the film-like quality it delivers
Pixel	individual PICture Element, the smallest discrete light sensitive element of a *CCD* or *CMOS* sensor

Quicktime

a multimedia system developed by Apple Computer able to handle various formats of digital video, audio files and images. Underpins many of the video applications on Macintosh computers and also available (and used) extensively on Windows PCs. Also used to replay video files downloaded or streamed from the internet

Resolution

the amount of detail in a video image. The greater the resolution the more detail present in the image. Larger *CCD* and *CMOS* sensors do (in general) offer higher resolutions

Rough cut

a sequence of video clips, shots or scenes assembled on the timeline without detailed editing, designed to provide a preview of a movie for editing and continuity assessment

Scrubber bar

a representation of the *timeline* (of a movie or an individual clip) along which the *playhead* can be dragged and trims or crops can be defined using the *playhead handles*

SD see *Standard definition*

SECAM

SEquential Couleur Avec Memoire. Television standard, similar to and with limited compatibility with *PAL*, used for *standard definition* television broadcasts in France, Russia and their respective former dependencies

Shelf see *Clip library*

Standard definition

non-high definition television. Used to describe conventional television standards based on 625 lines (*PAL* and *SECAM*) and 525 lines (*NTSC*)

Standards conversion

the process of converting a television signal from one standard to another, such as from *NTSC* to *PAL*. Tends to be used to describe conversions between analogue television standards

Storyboard comic strip-like layout used to outline the look and sequence of shots to be recorded for a video. Also used to describe a version of the *timeline* used in many video editing applications where clips are represented by thumbnails rather than bars proportional to their duration

Streaming video internet-delivered video that can be viewed while download is in progress

SuperVCD version of *VideoCD* that also uses CDs as a recording medium. Uses *MPEG-2* rather than *MPEG-1*, as for VideoCDs for higher picture quality

S video alternate name for *high band* video and also the name given to the respective connectors and connections between peripherals that carries *component video*

Timecode information encoded onto every frame of a digital video recording that uniquely defines it in terms of time and frame number. Can be used for editing purposes to get frame-accurate editing

Timeline visual representation of a video that illustrates the individual clips or scenes along with one or more soundtracks.

Trimming the cutting away of selected material in a video clip. Compare with *cropping*

Video 8 consumer video format that uses small-size cassettes and 8 mm wide video tape. Superseded by the *high band* version, Hi8 and later by *Digital-8* which used similar or identical tapes

VideoCD video compact disc. Video recording format that uses *MPEG-1 compression* to allow around one hour's video to be recorded in a standard CD at VHS quality. See also *SuperVCD*

White balance

camera setting and control that adjusts the colour balance of the recorded images so that objects which are notionally white or neutral in colour are rendered as such under different lighting conditions. Manual settings allow the strong colour casts (for example from domestic tungsten lighting) to be eliminated or, for creative effect, enhanced. Auto white balance settings constantly adjust the white balance

A chronology of cine and home movie making

1899 Birtac camera launched using 17.5 mm filmstock (half the width of standard 35 mm film)

1922 Pathe introduce the first popular (in relative terms) amateur format: 9.5 mm

1923 16 mm filmstock debuts

1920s William Friese Greene shoots colour movies using filters and black-and-white filmstock

1925 Kodak introduces Cine Kodak Model B, a clockwork powered model designed for the 'serious enthusiast'

1932 Cine Kodak Eight (later known as Standard 8) filmstock introduced. Just 8 mm wide, it was cheap enough for the amateur market

1930s Colour versions of 16 mm and 9.5 mm filmstock introduced

1936 Cartridge loading films introduced for some 16 mm models, adding to the convenience of movie making

1950s Standard 8 cameras widely adopted by hobbyists and enthusiasts

1965 Super 8 Film introduced. Cartridge based, and with a 50 per cent larger frame size than Standard 8

1965 Single 8, a variant of Super 8 using a different plastic film base and cassette (rather than cartridge) introduced

1960s	Use of Standard 8 filmstock and cameras wane following the appearance of Super 8
1983	Sony introduce first camcorder using full size Betamax tapes
1984	Kodak (and others) introduce camcorders based on full-size VHS cassettes
1985	Sony introduce the Handycam, a compact camcorder based on the smaller Video 8 tape format
1994	Kodak stops production of Standard 8 films. Monochrome Standard 8 still produced in Eastern Europe
1996	The Digital Video format DV is introduced, with miniDV designed for use in consumer level camcorders
1997	The digital versatile disc (DVD) introduced as a replacement for several existing audio and video formats
1998	Sony introduce the final refinement to Video 8 with Hi8-XR
2001	Sony introduce the **microMV** format based around MPEG-2 compression and using cassettes substantially smaller than those of MiniDV
2003	High definition format HDV announced. Uses MPEG-2 compression and the same tape cassettes as MiniDV
2006	Blu Ray and HD DVD disc recorders and players debut for the consumer, allowing high definition video to be shared

taking it further

I hope this book has inspired you to take those next steps in movie making and set you on a course to produce your first blockbuster! To help you along the way, why not check out these online resources, all packed with advice and help.

Unhollywood (www.unhollywood.com)
A website devoted to keen movie makers working on limited budgets (or microbudgets, as the site points out). If you're on the point of wanting to make the leap from home movies to commercial movies – or are curious to see what can be done for next to nothing – this is a great site to visit.

YouTube (www.youtube.com)
The ubiquitous video publishing site isn't just a great way to publish your own productions, it's also ideal for taking a look at the techniques – and ideas – of your movie making peers. It's extensive in scope so you have plenty of choice.

Google Video (http://video.google.co.uk)
The equally pervasive Google also has a video library feature (hardly surprising as Google now also owns YouTube). Google Video ranks its most popular videos and includes a range of featured titles. There's also a listing – constantly changing – of movers and shakers of the video world and a ranked Top 10 videos.

Filmmaking.net (www.filmmaking.net)
Promoting itself as one of the oldest filmmaking resources sites on the internet, it's full of all the sort of information you need when making movies – FAQs, lists of equipment and software, and, perhaps most usefully, extensive discussion forums.

Screenwriting.info (www.screenwriting.info)

If you're getting serious about the structure of your movies it'll need a good script. Screenwriting.info is an ideal starting point and will take you through all aspects of writing a script.

Digital Video (www.dv.com)

The website that accompanies the industry-leading magazine of the same name is a portal into all things DV. You'll find roundups of hardware, software, cameras and more, all from a pro or semipro perspective. If you're serious about your movie making, this is a great page to bookmark.

Videoguys.com (www.videoguys.com)

Another comprehensive informational source that is particularly focused on high definition (HDV) video production. If you are looking at taking your first steps – or further steps – into high-definition video, this is a great place to start. It's run by some true enthusiasts, so the information is spot on and relevant.

index